IMAGES
of Aviation

AIRPLANE MANUFACTURING IN FARMINGDALE

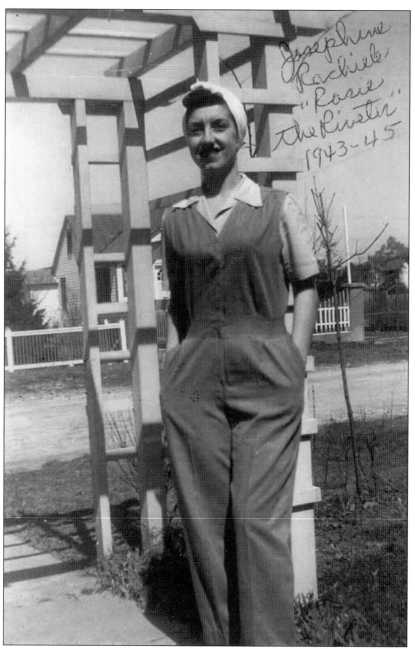

Josephine Rachiele, "Rosie the Riveter" 1943-45

Women were a major part of aviation history in Farmingdale, New York. Josephine Rachiele, famed Republic Aviation "Rosie the Riveter," stands in her Republic coveralls outside her home in West Babylon. Josephine and her sisters, Sarafina and Teresa, worked at Republic during World War II. Josephine was employed by Republic and Fairchild Republic for over 40 years and was involved in the building of the P-47, F-84, F-105, A-10, and T-46A. (Courtesy of Josephine Rachiele.)

ON THE COVER: Republic Aviation P-47D Thunderbolt Razorbacks are pictured on Republic's three assembly lines in Building 17 on March 15, 1944. (Courtesy of Republic Aviation Archives, LIRAHS.)

IMAGES
of Aviation

AIRPLANE MANUFACTURING IN FARMINGDALE

Ken Neubeck and Leroy E. Douglas
with the Long Island Republic Airport
Historical Society

ARCADIA
PUBLISHING

Published by Arcadia Publishing
Charleston, South Carolina

Printed in the United States of America

Library of Congress Control Number: 2015948904

For all general information, please contact Arcadia Publishing:
Telephone 843-853-2070
Fax 843-853-0044
E-mail sales@arcadiapublishing.com
For customer service and orders:
Toll-Free 1-888-313-2665

Visit us on the Internet at www.arcadiapublishing.com

CONTENTS

ACKNOWLEDGMENTS

The Long Island Republic Airport Historical Society (LIRAHS) was created by the New York State Department of Transportation (NYSDOT) and the Republic Airport Commission in 1984 to educate the public about the history of aviation at the airport and in the Farmingdale-Babylon, New York, area. Without the support of the NYSDOT and the space it has provided us to house our archives and hold our meetings, this book could not have been developed. We are especially in debt to the two men who have directed Republic Airport for the NYSDOT—Hugh D. Jones and Michael Geiger—and to Shelley LaRose Arken, the manager of Republic Airport, for their assistance in supporting the Long Island Republic Airport Historical Society. This book has been created on behalf of and with the full cooperation of the officers and trustees of the Long Island Republic Airport Historical Society.

Our extensive photo archives were developed by Edward "Jim" Boss and Lynn McDonald under the supervision of our first president, Charlotte Geyer, who also served on the Republic Airport Commission. We thank the following institutions and individuals for providing many of the photographs used in this book: Joshua Stoff, curator of the Cradle of Aviation Museum in Garden City, New York; Elizabeth C. Borja, reference services archivist at the Smithsonian National Air and Space Museum Archives of the Steven F. Udvar-Hazy Museum in Chantilly, Virginia; David R. Schwartz at the Smithsonian; Karen Igoe, photograph permissions at the Smithsonian; Julia Lauria-Blum, archivist at the Cradle of Aviation Museum in Garden City, New York; Iris Levin at the Nassau County Parks, Recreation & Museums Photo Archives in Old Bethpage, New York; Shelley LaRose Arken, manager of Republic Airport; Deanna Wilson, FAA tower chief at Republic Airport; Jeff and Jacky Clyman at the American Airpower Museum; Seth Purdy, Pat Cahaney, and William Lauder at the Amityville Historical Society; and Terry Alleg, Charlie Bowman, Rob Hammerquist, Mike Morra, John Musolino, and Peter Zuzulo of the LIRAHS. Also, thanks to Thomas Joyce, head of the Northrop Grumman Intellectual Property section in California, and Lawrence A. Feliu, manager of the Northrop Grumman History Center in Bethpage, for facilitating our use of the Grumman photographs. We also thank those dedicated scholars—such as Alan Abel, Warren M. Bodie, Kent Mitchell, and Joshua Stoff—whose books on Fairchild, Seversky, and Republic Aviation have greatly assisted us. We thank Stella Barbera for the many hours she put into proofreading this manuscript.

Images in this volume appear courtesy of the Cradle of Aviation Museum (CAM), the Long Island Republic Airport Historical Society (LIRAHS), Northrop Grumman Corporation (NGC), the Smithsonian National Air and Space Museum Archive (NASM), the Amityville Historical Society (AHS), and the Farmingdale-Bethpage Historical Society (FBHS).

INTRODUCTION

For almost a century, Farmingdale, New York, has been a major center of airplane manufacturing and airport operations. In 1917, the same year that the Curtiss Aircraft Company opened its experimental factory in Garden City, Lawrence Sperry—the founding father of airplane manufacturing in Farmingdale—established his airplane factory in the village. During World War I in 1918, Sperry built two amphibious triplanes for the US Navy, and the (Sydney) Breese Aircraft Company in East Farmingdale built 300 non-flying basic trainers for the US Army. Before Sperry's tragic death in December 1923, his employees in Farmingdale and South Farmingdale assembled 42 light Messenger aircraft and three sleek R-3 racers for the US Army.

In 1926, Sherman Fairchild established airplane manufacturing and airplane engine production in the former Sperry factory in South Farmingdale. Fairchild's workers built the innovative FC cabin airplanes and Fairchild Caminez engines in South Farmingdale before moving to a larger and more modern factory complex and flying field in East Farmingdale in 1928. The stock market crash of 1929 and the Great Depression had a devastating impact on airplane manufacturing. Fairchild moved his airplane manufacturing to Hagerstown, Maryland, in 1929, and his airplane engine factories were taken over by the Aviation Corporation and renamed American Airplane & Engine Corporation. But they too succumbed to the depressed demand of the Great Depression in 1931.

In 1932, Grumman Aircraft Corporation moved to East Farmingdale and built its early aircraft (such as FF fighters, JF amphibians, and F3F fighters) for the US Navy in the former Fulton Truck Company factory from 1932 to 1937. In 1934, Sherman Fairchild returned to Farmingdale and resumed building airplane engines in his Ranger Aircraft Engines factory. Ranger Aircraft Engine Division, known as Fairchild Engine Division after 1950, built engines for the US Army and US Navy until the company moved to Deer Park in 1956. From 1939 until 1957, the Liberty Aircraft Finishing Corporation on the former Sperry-Fairchild site in South Farmingdale did important subcontracting work for Grumman and Republic. Also in 1935—a turning point in the takeoff of major airplane manufacture in Farmingdale—Alexander de Seversky moved his airplane manufacturing into the former Fairchild and American factory buildings. There, employees led by his brilliant chief engineer, Alexander Kartveli, built outstanding aircraft, such as the P-35, for the US Army Air Corps.

In 1939, Seversky Aircraft was reorganized as the Republic Aviation Corporation, and Alexander Kartveli and his engineering team developed the powerful P-47 Thunderbolt fighter-bomber. The US government funded the construction of a new, much larger Republic Aviation factory complex in 1941 and the development of a larger Republic Airfield, which allowed the construction and flight testing of 9,087 P-47s between 1942 and 1945. The Thunderbolts played a major role in protecting US Army Air Force bombers over France and Germany during World War II and in devastating German ground targets.

While aviation started in Farmingdale with cloth-covered triplanes and biplanes and prop engines, after World War II, Republic helped move the United States into the jet age with the

F-84 and F-84F, which assisted US forces in Korea and NATO nations in the 1950s. Republic then developed the massive F-105 Thunderchief, which was used widely during the Vietnam War. Although Republic had tried to diversify airplane manufacturing with the RC-3 Seabee and the XR-12 Rainbow after World War II, these efforts were not financially successful. As production of the F-105 was winding down in 1965, Sherman Fairchild returned to Farmingdale, acquired Republic, and renamed it Fairchild Hiller and then Fairchild Republic in 1972. Before obtaining major work for the famed Fairchild A-10, Fairchild did subcontracting work with tail assemblies on the McDonnell F-4 Phantom and leading edges for the Boeing 747, as well as producing the vertical stabilizer tails for the space shuttles. While Fairchild Republic workers in Farmingdale constructed wings and fuselages for the A-10, final tail assembly and flight-testing were conducted in Hagerstown, Maryland. The A-10 has provided outstanding wartime service in both Iraq wars, in Afghanistan, and in current US operations against global terrorism. Fairchild Republic built 50 sets of landing gear doors and fairings for the Lockheed C-5B Galaxy between 1982 and 1987. Fairchild tried but failed to win a production contract from the US Air Force for the T-46A trainer, and the company closed its factory doors in 1987, ending 70 years of airplane manufacturing in Farmingdale.

The closing of Fairchild Republic did not end aviation in Farmingdale. Republic Airfield became Republic Airport in 1966 and has been operated as a publicly owned general aviation airport by the Metropolitan Transportation Authority (1969–1982) and by the New York State Department of Transportation since 1983. With its two long runways, instrument landing system, control tower, several aviation service businesses, and the impressive American Airpower Museum, Republic Airport plays an important part in the national and global air transportation network. It is an important contributor to the economy of Long Island and the New York metropolitan region. Thus, Republic Airport carries on the tradition of aviation established by Lawrence Sperry in Farmingdale almost a century ago.

One

THE FOUNDATION YEARS
1917–1931

Just 14 years after Orville and Wilbur Wright's first flight in Kitty Hawk, North Carolina, airplane manufacturing came to Farmingdale, New York, in 1917. For 70 years, from 1917 until 1987, Farmingdale was a leader in airplane manufacturing.

Farmingdale straddles the Nassau-Suffolk County border in west central Long Island. For over 200 years before the beginning of airplane manufacture, Farmingdale was a rural agricultural community. The Industrial Revolution and airplane manufacture came to Farmingdale during World War I when Lawrence Sperry and Sydney Breese established their pioneering factories in the community. They were drawn by the presence of two branches of the Long Island Railroad (the Main Line, 1841, and the Central Branch, 1873); the nearby Route 24, which brought auto and truck traffic to and from the Fifty-Ninth Street Bridge in Manhattan; the level outwash plain, which provided land for flying fields; and the proximity to skilled workers on Long Island and in New York City. A number of different aircraft models were built at this location.

After the failure of Breese Aircraft and the untimely death of Lawrence Sperry, Sherman Fairchild advanced airplane and airplane engine manufacture in 1926 when he moved into the former Sperry factory in South Farmingdale. In 1927–1928, seeking larger quarters and a more spacious airfield, Fairchild moved his Fairchild Aviation Center to East Farmingdale in Babylon, Suffolk County. The airplane and engine factories were taken over by the Aviation Corporation conglomerate in 1931 but closed shortly after due to the contraction of demand for airplanes, especially civilian aircraft, during the Great Depression. Sperry, Fairchild, and Breese built about 750 airplanes and trainers in Farmingdale between 1917 and 1931.

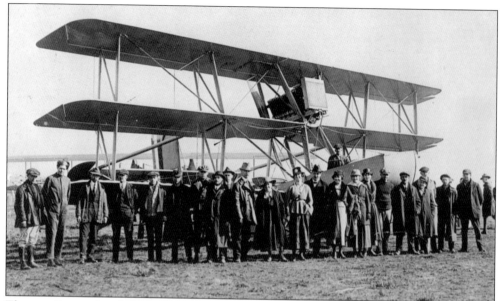

The two Sperry Amphibious Triplanes, the first aircraft built in Farmingdale, are seen at the Sperry Seaplane base in Amityville in 1918 with Lawrence Sperry standing second from the left. Sperry Triplanes, with their pusher engines, were built as coastal defense bombers for the US Navy. (Courtesy of Amityville Historical Society.)

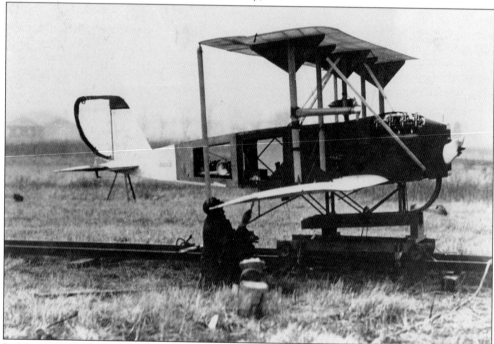

In May 1917, the US Navy financed the modification of five Curtiss N-9 seaplanes using Sperry gyrostabilizer and distance gear technology to provide a pilotless "flying bomb." Lawrence Sperry, the founding father of aviation in Farmingdale, directed the first successful 1,000-yard aerial torpedo flight from Amityville to Copiague over the Great South Bay in March 1918. (Courtesy of CAM.)

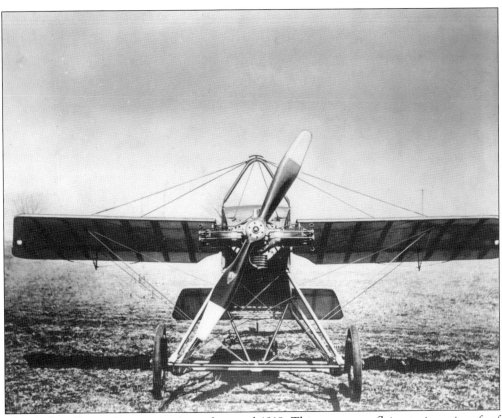

This Sydney Breese Penguin is pictured around 1918. This was a non-flying trainer aircraft of which 300 were built for the US Army. It was designed to simulate the feel of a real aircraft for student pilots. The aircraft was powered by a small Lawrence engine and had short wings that kept it on the ground. (Courtesy of LIRAHS.)

Pictured is the inside of Sperry's factory in Farmingdale around 1920. Sperry contributed to several aircraft innovations, including the gyroscope and instruments for all-weather flying. (Courtesy of LIRAHS.)

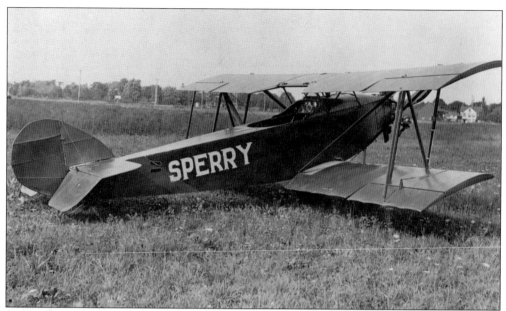

Lawrence Sperry Aircraft Company's M-1 Messenger is pictured on the 10-acre Sperry Flying Field in South Farmingdale in the early 1920s. The Verville-Sperry aircraft was driven by three-cylinder Lawrence engines. As requested by Gen. William "Billy" Mitchell, 42 Messengers were built for the US Army. All were built in Farmingdale (eight were constructed in Sperry's original factory in the ex-Bausch Picture Frame factory on Rose Street, and 24 in the former Raymond Engineering building on Motor Avenue). (Courtesy of NASM 9A12326.)

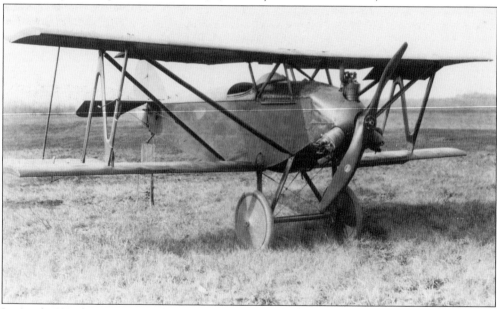

In April 1920, the US Army asked Lawrence Sperry to modify some of his planned lightweight Messenger aircraft to serve as pilotless aerial torpedoes. The Sperry Messenger MATs that Lawrence Sperry built in Farmingdale using advanced Sperry technology made very successful radio-controlled flights of 30, 60, and 90 miles and back to Mitchel Field in nearby Nassau County in June 1922. (Courtesy of CAM.)

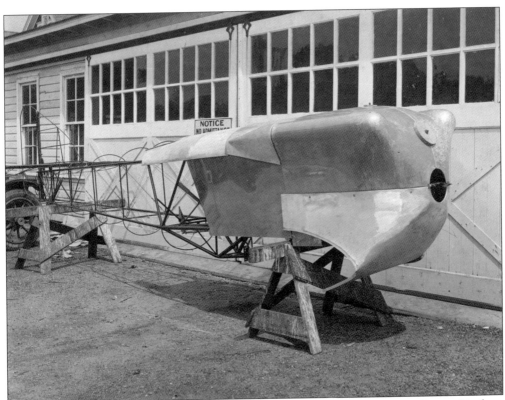

A Verville-Sperry R-3 racer is pictured under construction outside the Lawrence Sperry Airplane Company shop on Rose Street in the Village of Farmingdale in 1922. This is one of three low-wing, cantilever racing airplanes that Lawrence Sperry built for the US Army in Farmingdale in 1922. (Courtesy of LIRAHS.)

Lawrence Sperry Airplane Company workers perform a static load test of the tail skid during the assembly of the Verville-Sperry R-3 Racer at the Rose Street shop on September 5, 1922. (Courtesy of LIRAHS.)

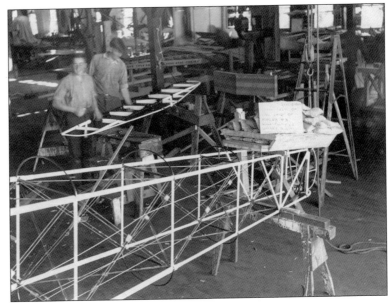

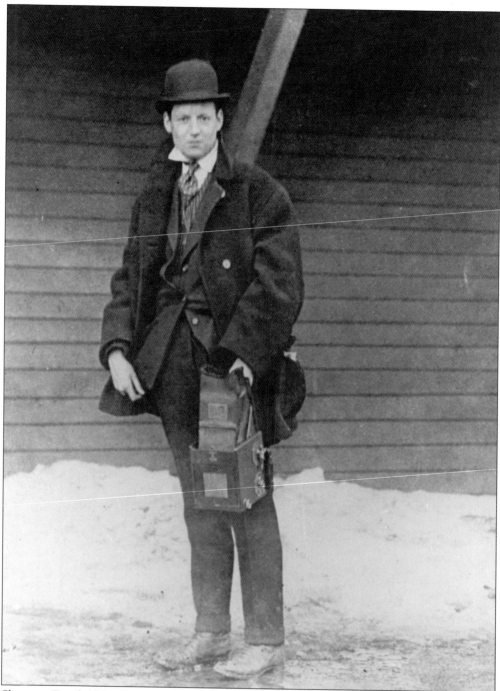

Sherman Fairchild began successfully building aerial cameras in 1920. This photograph shows Fairchild with one of his early cameras. Unhappy with the unstable and uncomfortable open-cockpit aircraft he was using for his aerial photography, Fairchild formed the Fairchild Airplane Manufacturing Corporation in 1925 to design and develop an airplane as a suitable platform for his aerial surveying. (Courtesy of CAM.)

This early aerial photograph of the East Farmingdale area was taken around 1920. Sherman Fairchild built his aircraft and aircraft engine factories and his flying field in 1928 at the location in the left center of the photograph. (Courtesy of LIRAHS.)

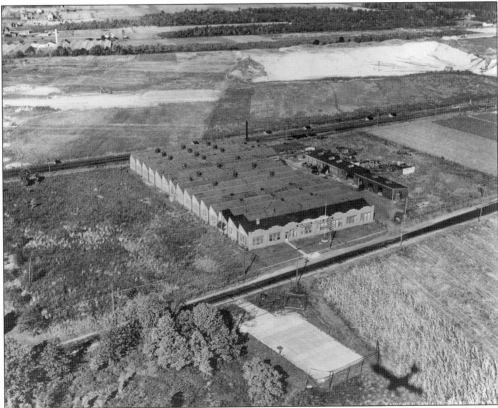

This aerial view shows the former Fulton Truck Factory in 1927, which was used by McAvoy Homes Inc. just before Sherman Fairchild bought the property and developed his factories and flying field there. The factory lies between the Long Island Railroad (LIRR) and Conklin Street. Sherman Fairchild built pontoons in this building in 1927. (Courtesy of LIRAHS.)

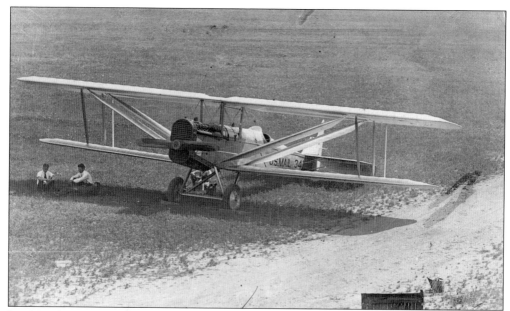

In 1924, Giuseppe Bellanca designed improved wings for the US Post Office DH-4 aircraft, and the rework was performed in the former Lawrence Sperry factory building in Farmingdale. The wings were an improvement over the original design, but only a few aircraft were actually modified. (Courtesy of NASM 2003 30923.)

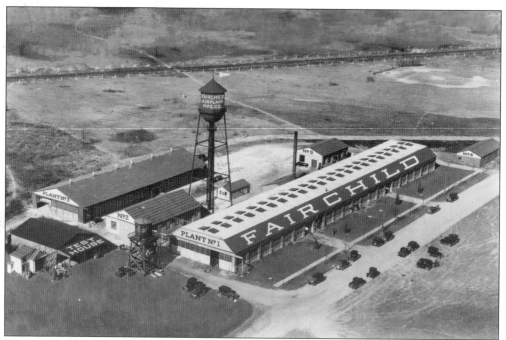

This detailed aerial photograph shows the five buildings of the Fairchild Airplane Manufacturing Company facilities in South Farmingdale around 1926–1927. Airplanes were built in Plant No. 1, and engines were assembled in Plant No. 3. The LIRR central branch is located at the top, and the flying field is at lower right. (Courtesy of NASM 9A12325.)

A skilled Fairchild-Caminez Engine Corporation worker is using a Jones & Lemson "Harkness" flat turret lathe to help produce the Caminez Model 440-C aircraft engine inside the South Farmingdale factory around 1926–1927. (Courtesy of NASM 9A12315.)

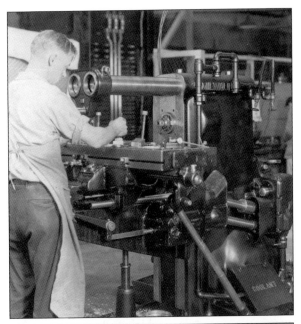

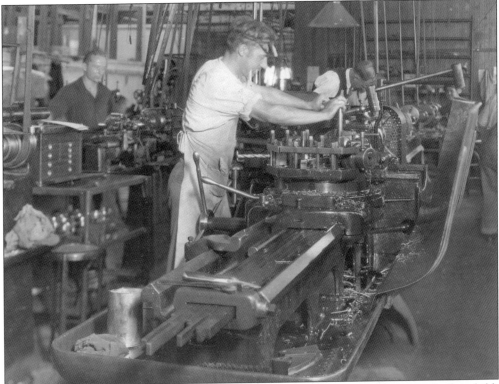

A skilled machinist uses a Kearney & Frecker plain miller during production of a Fairchild-Caminez Engine Corporation Model 440-C double-lobed "Cam" aircraft engine inside the South Farmingdale factory around 1926–1927. When Harold F. Caminez left Fairchild, the Fairchild Engine Corporation was created in May 1929 under the leadership of Walter Davis and John B. Tallman. (Courtesy of NASM 9A12313.)

This aerial photograph shows the Fairchild Airplane and Caminez Engine factories in South Farmingdale looking towards the Village of Farmingdale, around 1926–1927. Five FC-2s are parked on the grass flying field, located to the south of the complex. A Fairchild Flying School sign is on the left. (Courtesy of NASM 9A12324.)

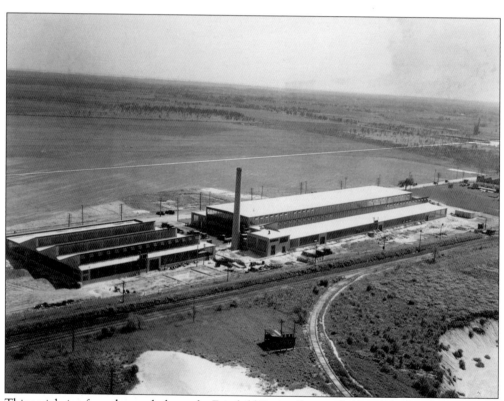

This aerial view from the north shows the Fairchild Engine Factory (left) and the Fairchild Airplane factory (right) nearing completion in East Farmingdale during the spring of 1928. The Fairchild Metal Boat Division and Service Building is located at far right, with the flying field at the top. The Long Island Railroad main line is in the foreground. (Courtesy of NASM 9A12319.)

Tubular steel frames for a Fairchild FC-2 are under construction inside the Fairchild Airplane factory in South Farmingdale in 1926–1927. Fairchild would move to larger quarters in East Farmingdale in 1928 to build more aircraft using an assembly line. (Courtesy of NASM 9A12318.)

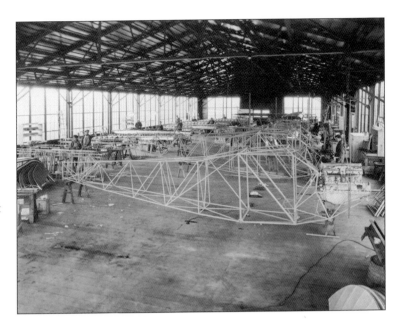

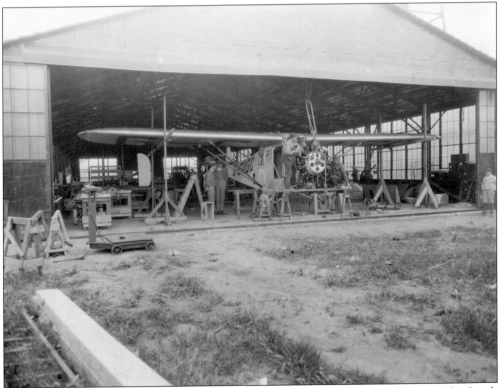

A Fairchild FC-2 G-CAGC all-purpose cabin monoplane is nearing completion in the South Farmingdale factory for Fairchild Aerial Survey of Canada Ltd. in July 1927. This particular aircraft was destroyed during a landing in northwestern Quebec in August 1930. (Courtesy of NASM 9A12322.)

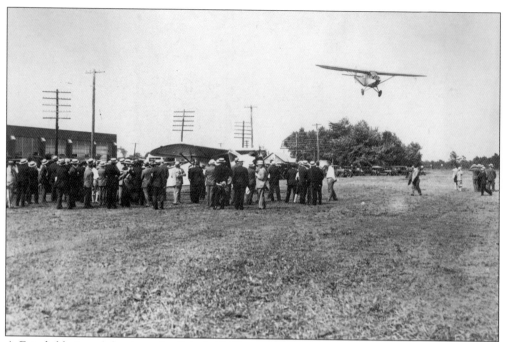

A Fairchild aircraft lands at the Fairchild Flying Field in East Farmingdale in June 1928 as a group of invited guests watch. This occurred at the same time that the Fairchild Aviation Center, with its airplane factory, engine factory, and service hangar, opened for business. (Courtesy of NASM 9A12320.)

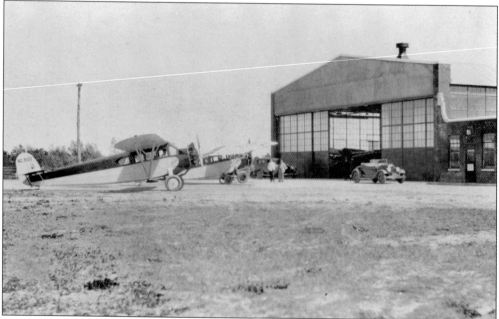

Fairchild Model 71 aircraft are outside Fairchild's 1928 hangar on the east side of the Fairchild Flying Field, alongside New Highway. The hangar would be used by Fairchild, American, Grumman, Seversky, Republic, and Fairchild Republic. It is the only 1928 Fairchild hangar that is still used at Republic Airport. (Courtesy of NASM 9A12333.)

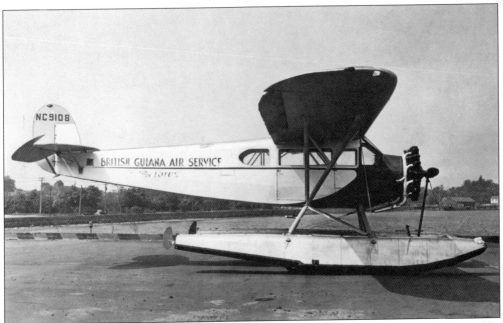

This Fairchild Model 71 aircraft is outfitted with Fairchild-manufactured floats and was used by British Guiana Air Service to provide charter flights to the interior of Guyana as well as airmail service inside and outside the country. Fairchild was a global business in the 1920s, with its aircraft used around the world. (Courtesy of NASM 9A12332.)

This Fairchild Model 41A aircraft on the company landing field was a refinement of the high-wing Fairchild 41, which was first flight-tested on November 19, 1927. One Model 41 and one 41A prototype were built, along with eight Model 42s, but the stock market crash in October 1929 ended demand for luxury aircraft. (Courtesy of NASM 9A12330.)

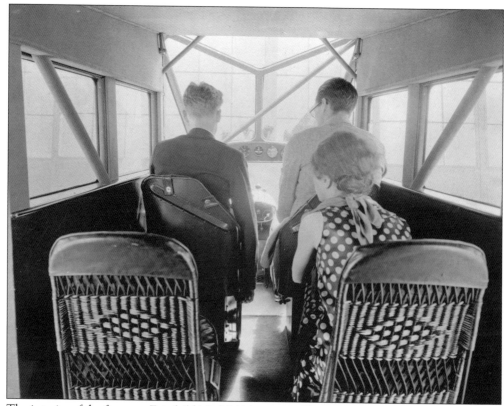

The interior of the four-seat Fairchild Model 41A, pictured here, featured a small but comfortable cabin that was designed by John Lee. The aircraft utilized a 300-horsepower engine. (Courtesy of NASM 9A12331.)

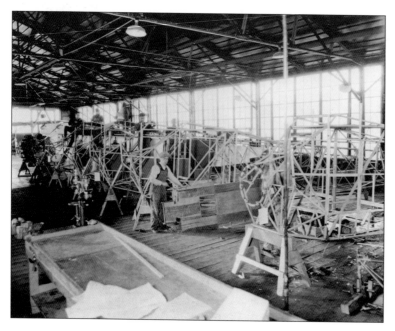

This is the assembly line for the Fairchild FC-2 aircraft in the South Farmingdale aircraft factory in 1926 or 1927. The strong FC-2 frame was made with welded steel tubing. (Courtesy of NASM 9A12321.)

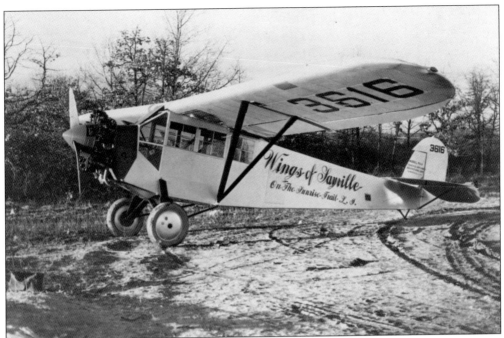

This Fairchild FC-2 "Wings of Sayville: On the Sunrise Trail L.I." aircraft was delivered from Fairchild in February 1928 to Suffolk County as part of a promotional campaign for the renaming of Route 27. Powered by a 200-horsepower Wright J-4 Whirlwind radial engine, the aircraft was later sold to Canadian Airways in 1928 and destroyed in an accident at Quebec in April 1930. (Courtesy of NASM 9A12327.)

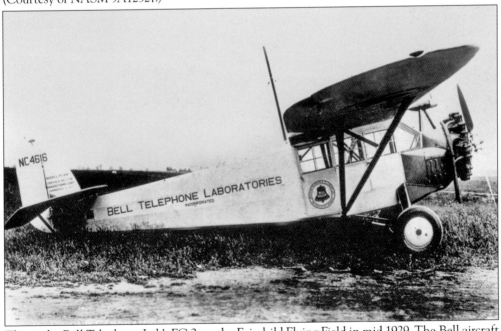

This is the Bell Telephone Lab's FC-2 on the Fairchild Flying Field in mid-1929. The Bell aircraft was the first plane Sherman Fairchild's men manufactured in East Farmingdale. It was used by Bell Labs for important air-to-ground telephone experiments. (Courtesy of LIRAHS.)

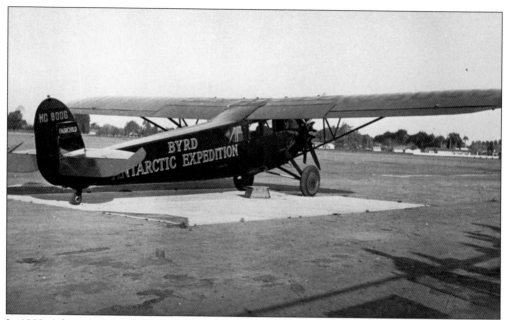

In 1929, Admiral Richard E. Byrd began his first expedition to the Antarctic, involving two ships and three airplanes—one of which was a Fairchild FC-2W2 named *Stars and Stripes*. Photographic expeditions and geological surveys were undertaken by Byrd and the Fairchild FC-2W2 in 1934. (Courtesy of Nassau County Parks, Recreation & Museums.)

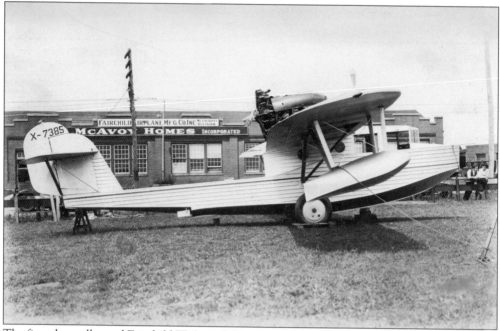

The five-place, all-metal Fairchild FB-3 amphibian was designed by Arthur Stelb, the top engineer at the Fairchild Metal Boat Division in Farmingdale. Only one richly appointed FB-3 driven by a 410-horsepower Pratt & Whitney Wasp B engine with a pusher propeller was built in 1929. The FB-3 was another Fairchild Aviation victim of the 1929 stock market crash. The McAvoy Homes building is in the background. (Courtesy of NASM 9A12329.)

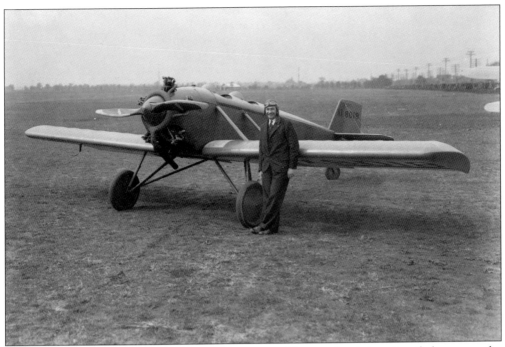

Sherman Fairchild had Otto Koppen design a reasonably priced training aircraft, known as the Fairchild FT-1/Model 21 in 1928. The low-wing aircraft had two cockpits with dual controls, was powered by an 80-horsepower Armstrong-Siddeley Genet five-cylinder radial engine, and was priced at $4,250. (Courtesy of NASM 9A12328.)

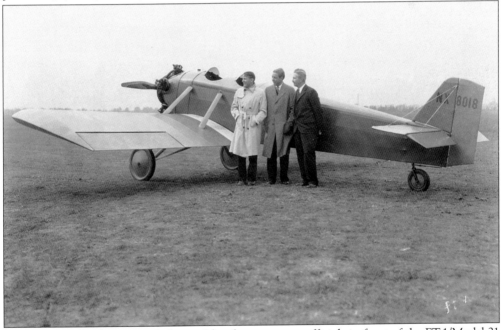

Sherman Fairchild is pictured along with other company officials in front of the FT-1/Model 21 prototype aircraft on the flying field near his plant. The aircraft was discontinued after the stock market crash, with only two prototypes built. (Courtesy of LIRAHS).

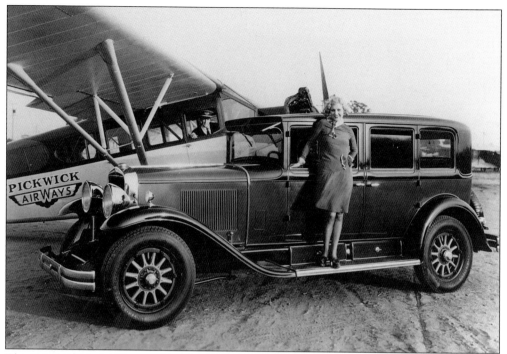

This Fairchild Model 71 aircraft was built in East Farmingdale in April 1929 for Pickwick Airways of Los Angeles for use on air transport and charter flights in the Southwest. Pickwick was given a 10 percent dealer discount, paying $15,305 for the seven-seat aircraft, which weighed 5,500 pounds. This photograph illustrates the use of sex and style in advertising in the United States in the late 1920s. (Courtesy of NASM 9A12335.)

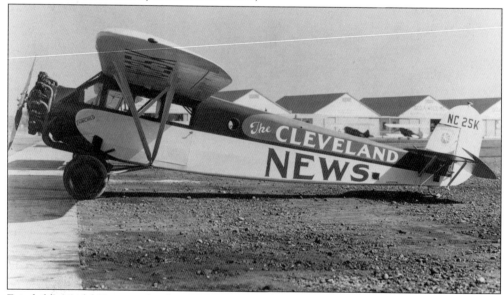

Fairchild's Model 71 general utility transport aircraft was used as an airliner, as a cargo plane, by the military, and for aerial photography in the United States, Alaska, Canada, and both Central and South America. This Model 71 was used by executives of the *Cleveland News*. (Courtesy of NASM 9A12336.)

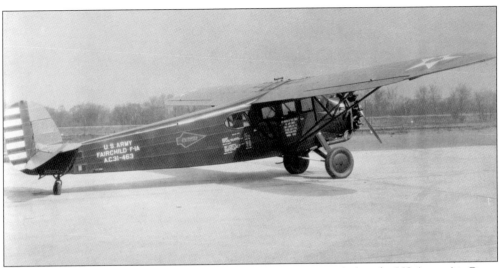

This is one of six Farmingdale-built Fairchild Model 71-F1A aircraft that the US Army Air Corps purchased and designated as an F-1A. This aircraft was used by the Army for aerial photography and was driven by a 420-horsepower Pratt & Whitney Wasp C nine-cylinder radial air-cooled engine. (Courtesy of NASM 9A12337.)

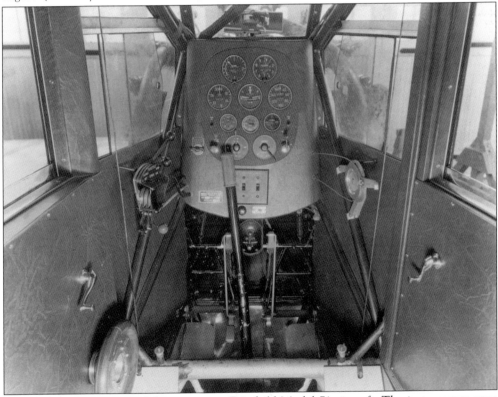

This is the pilot section of the seven-seat Fairchild Model 71 aircraft. The instruments were placed closer together and were better located for the pilot than on the earlier Fairchild aircraft. A total of 94 of these aircraft were built in Farmingdale between 1928 and 1931. (Courtesy of NASM 9A12342.)

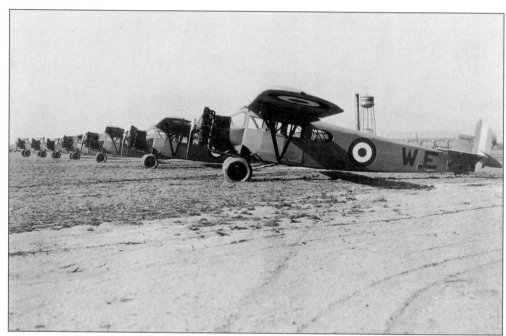

Fairchild Model 71 aircraft with Royal Canadian Air Force markings are pictured in formation on the field. Fairchild set up a separate facility in Quebec to build this version, and it was in service from 1930 through 1946. It was used for aerial photography. (Courtesy of LIRAHS.)

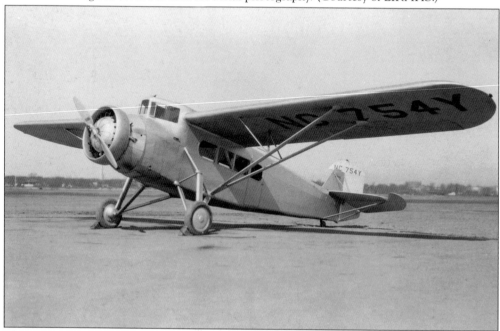

The Fairchild 100 prototype was a high-wing, 10-seat, fabric and metal aircraft. Designed by Virginius Clark, the Fairchild 100 was powered by a 575-horsepower Pratt & Whitney Hornet engine and was first flown on October 22, 1930. After the Aviation Corporation took over Fairchild, American Airplane in Farmingdale built sixteen 100As and six 100Bs to be used as airliners. (Courtesy of NASM 9A1238.)

This is the wooden and metal frame of a Fairchild Model 100 outside the Fairchild Engine factory on the north side of Conklin Street in East Farmingdale. (Courtesy of LIRAHS.)

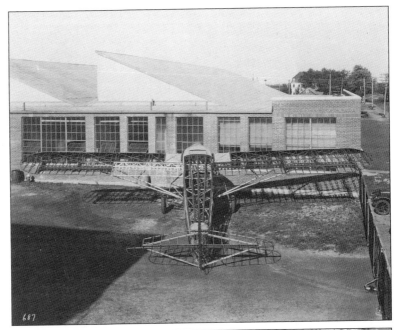

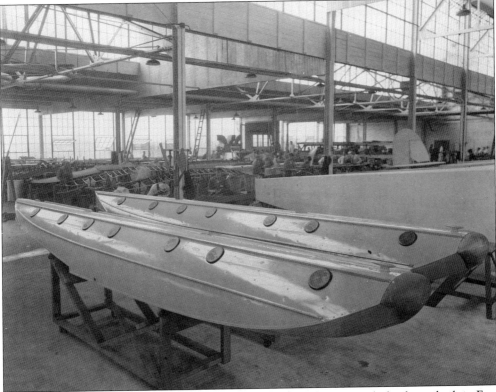

These are sleek Fairchild pontoon floats for amphibian aircraft, pictured after being built in East Farmingdale around 1928–1929. The Fairchild floats were made with wood frames covered with duralumin sheeting. The float could carry an anchor inside, and the axle holes could be fitted with beaching wheels. (Courtesy of NASM 9A12312.)

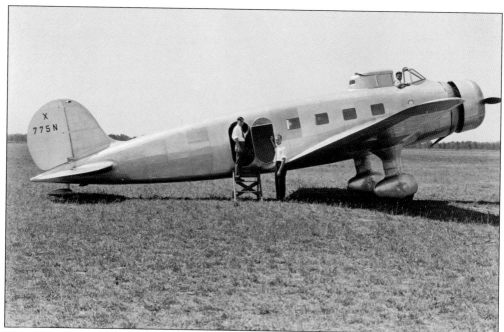

This 10-passenger, low-wing, all-metal, two-pilot Fairchild 150/American Pilgrim commercial transport aircraft was designed by Virginius Clark. The pilot cockpit was higher than the passenger level. It was powered by a Wright Cyclone engine and was first flown on May 22, 1932. General Motors' General Aviation Manufacturing Corporation bought the rights to the aircraft and built five in its Maryland factory. (Courtesy of NASM 9A12341.)

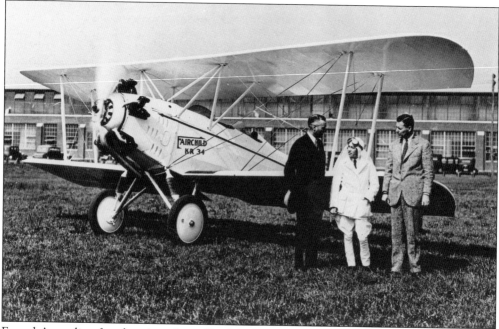

Famed Australian female aviator Jessie Keith-Miller stands with Carl Reed (left) and Sherman Fairchild in front of her Fairchild KR-34C, just before leaving Farmingdale to participate in the 16-day, 5,017-mile, 1929 National Air Tour. She finished in eighth place. (Courtesy of LIRAHS.)

Two

THE TAKEOFF YEARS
1932–1938

As the United States entered the third year of the Great Depression in 1932, all the airplane factories in Farmingdale were shuttered, and the grass grew tall on the former Fairchild Flying Field. It looked as though the airplane industry was dying the way the automobile industry (Fulton Truck and Victor Page Automobiles) had ceased to exist in this area in the early 1920s. Then, in November 1932, Leroy Grumman, Leon "Jake" Swirbul, William "Bill" Schwendler, and about 90 other Grumman Aircraft workers moved into the former Fulton Truck–Fairchild Service Building in East Farmingdale. Grumman built 27 FF-1s, 25 FF-2 trainers, 33 SF-1s, 55 F2F-1s, and 54 F3F-1s for the US Navy and 15 JF-2 Ducks for the US Coast Guard. Grumman had almost 400 employees when it moved to nearby Bethpage in April 1937.

In early 1935, Alexander de Seversky relocated his Seversky Aircraft Corporation from College Point in Queens to the former Fairchild Airplane factory in East Farmingdale. Led by his brilliant engineer Alexander Kartveli, Seversky built innovative aircraft (such as the BT-8, P-35, and the 1XP, S-2, and AP-7 racers) until he was fired in 1939 and the company renamed Republic Aviation.

Sherman Fairchild bought back his former engine company from the Aviation Corporation, renamed it Ranger Aircraft Engine, and resumed building in-line Ranger aircraft engines for the Army and Navy. By 1937, as aeronautical engineering was making great strides, the stage was set for the outstanding aircraft production at Republic and Grumman during World War II, which would make Farmingdale-Bethpage on Long Island world-famous for airplane production.

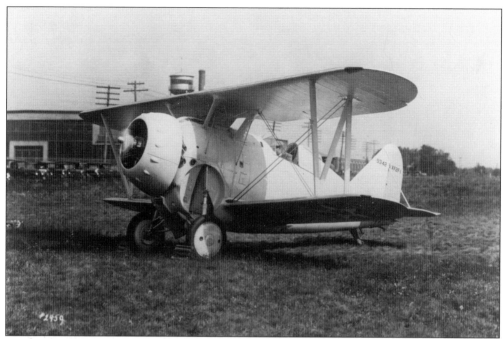

This Grumman F2F-1 was built for the Navy in East Farmingdale and test-flown by James H "Jimmy" Collins on October 18, 1933. The single-seat biplane featured retractable landing gear and an enclosed cockpit. In 1935, 54 F2F-1s were built for the Navy. (Courtesy of NGC.)

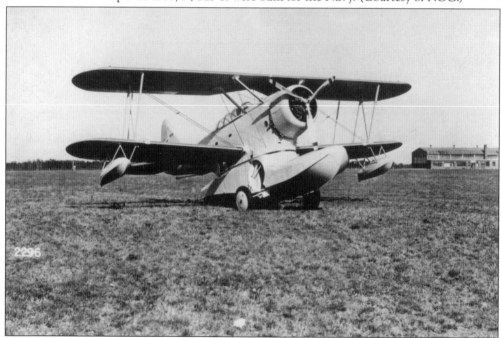

This Grumman XJF-1 prototype was the first of the Grumman amphibian aircraft and led to the successful Grumman JF-1, which was the first of several amphibians Grumman built for the US Navy. The two-seat biplane with float was driven by a Pratt & Whitney R-1535-62 engine. It was first flown from Farmingdale on April 24, 1933. (Courtesy of NGC.)

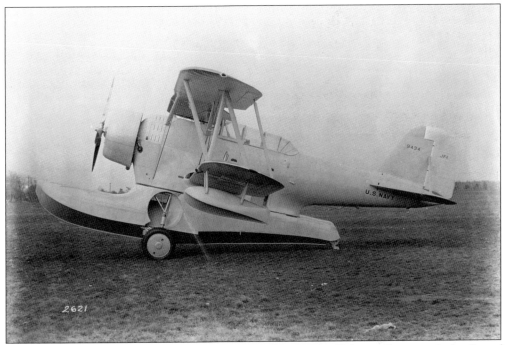

Grumman built 27 sturdy JF-1s in Farmingdale for the Navy and Marine Corps, with the first of these multi-use utility amphibians being delivered in May 1934. This close-up photograph was taken on the Grumman Flying Field in April 1934. (Courtesy of NGC.)

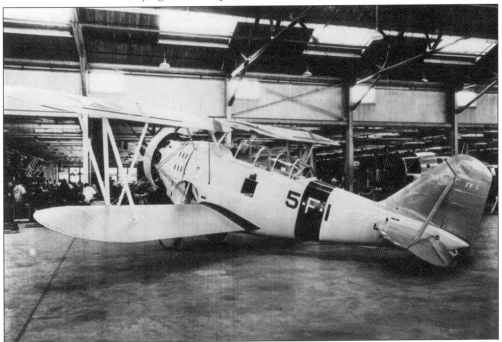

The Grumman FF-1 biplane was Grumman's original production aircraft for the US Navy in Farmingdale in 1933. Grumman moved into the ex-Fulton Truck factory in November 1932. (Courtesy of NGC.)

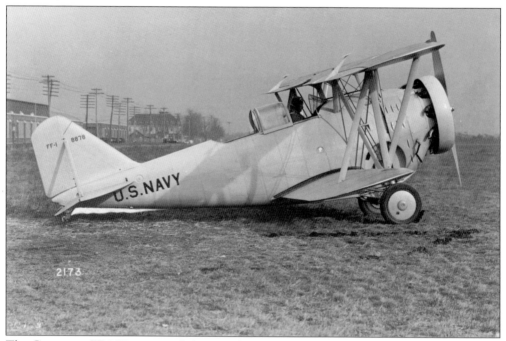

The Grumman FF-1-27 two-seat fighters with R-1820-78 engines were produced on the north side of Conklin Street in East Farmingdale for the Navy between April and November 1933. This FF-1 is on the former Fairchild Flying Field, where Grumman aircraft were flight-tested. (Courtesy of NGC.)

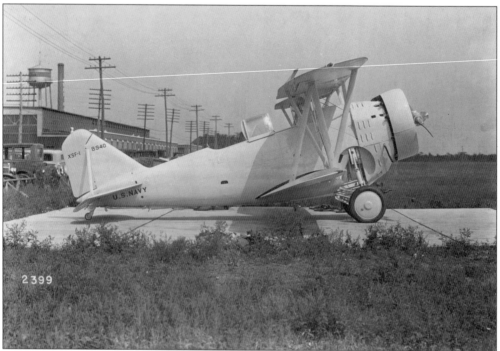

The XSF-1 aircraft was very similar to the FF-1 but had larger fuel capacity. It was built as a scout plane for aircraft carriers. Grumman built 33 SF-1s for the US Navy. (Courtesy of NGC.)

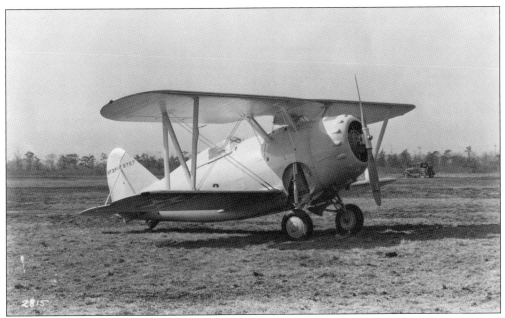

This is the Grumman XF3F-1 prototype, which was for Grumman's last biplane fighter. Jimmy Collins was killed during a final terminal velocity dive test in this airplane in Farmingdale on March 22, 1935. A total of 54 F3F-1s were built for the Navy. (Courtesy of NGC.)

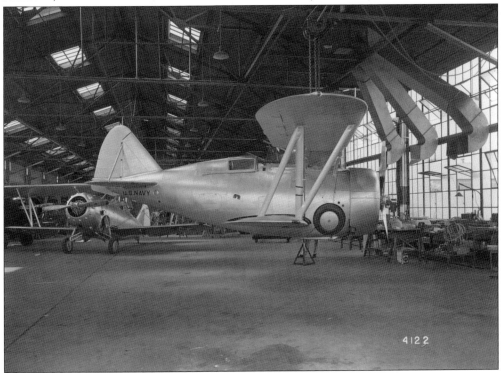

The Grumman XF3F-2 was similar to the F3F-1, but with a Wright XR-1820-22 engine. It was first flown on July 27, 1936, and 81 F3F-2s were built for the Navy in Farmingdale and then in Bethpage after Grumman moved there on April 8, 1937. (Courtesy of NGC.)

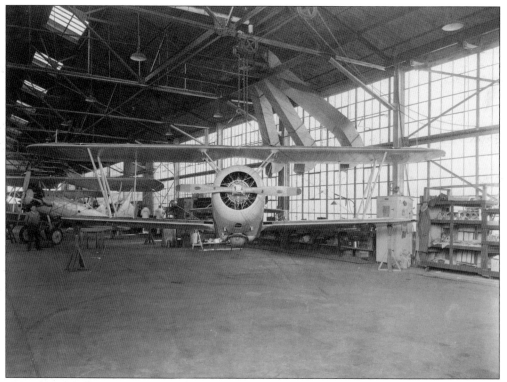

This photograph was taken inside the Grumman factory on the north side of Conklin Street. The XSBF-1 biplane was designed as a scout bomber and was first flown on December 24, 1935. The US Navy declined to fund production of the XSBF-1. (Courtesy of NGC.)

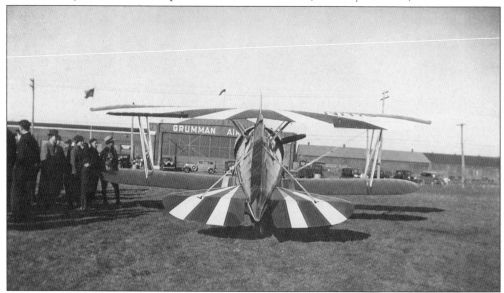

Grumman made the Gulfhawk biplane, which is based on the F3F model, for Gulf Corporation air show pilot Al Williams, who used the aircraft to demonstrate both Grumman and Gulf products. The aircraft is pictured in front of the Grumman Aircraft plant in Farmingdale in 1936. (Courtesy of NGC.)

This aerial view shows the original grass airfield as it appeared in 1935. Grumman was building airplanes in the building at the top left, Seversky at the top center, and Ranger Aircraft Engines in the building at the top right. All three used the field, known as American Airport. (Courtesy of CAM.)

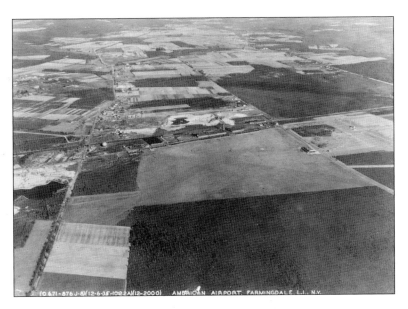

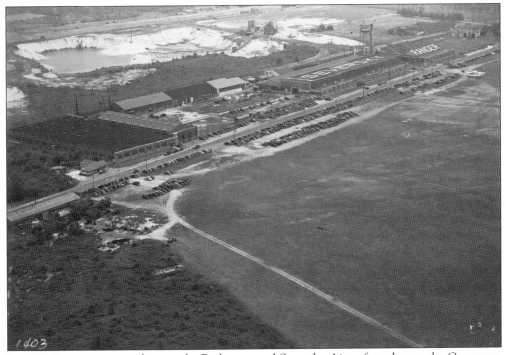

In 1937, Grumman moved to nearby Bethpage, and Seversky Aircraft took over the Grumman factory, seen in the upper left. The Seversky Aircraft factory is center right, and the Ranger Aircraft Engines division of Fairchild is at the upper right. Within four years, the flying field would be the site of the massive new Republic Aviation industrial complex. (Courtesy of CAM.)

Russian-born Alexander de Seversky was a major force in the aviation business. Despite losing his leg while conducting an aerial attack in World War I, he remained an active flyer. He brought his Seversky Aircraft Corporation to East Farmingdale in early 1935 from College Point. Seversky occupied the 1928 Fairchild Airplane factory, which was used earlier by American and Kirkham. Due to financial difficulties, he was forced out of the company in 1939, leading to the birth of Republic Aviation Corporation. (Courtesy of Seversky Archives, LIRAHS.)

This aerial photograph shows the two Seversky Aircraft factories and the Seversky Flying Field in Farmingdale. Seversky came to Farmingdale in early 1935. The building on the right is the Ranger Aircraft Engines factory, which Sherman Fairchild bought back from the Aviation Corporation in 1934. (Courtesy of LIRAHS.)

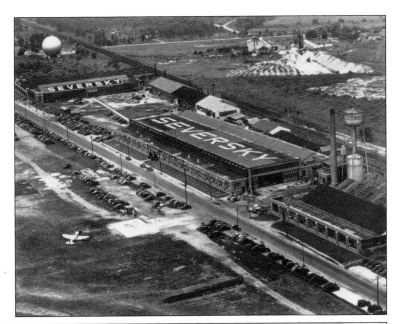

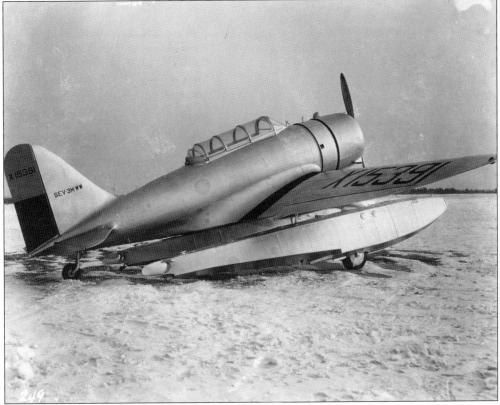

This is one of the three Seversky 3M-WW amphibian aircraft, which were built for the Colombian navy. The aircraft were started by Kirkham Engineering Corporation in the former Fairchild Airplane factory but were finished by Seversky in 1935. It was first test-flown by Alexander de Seversky in August 1935. (Courtesy of Seversky Archives, LIRAHS.)

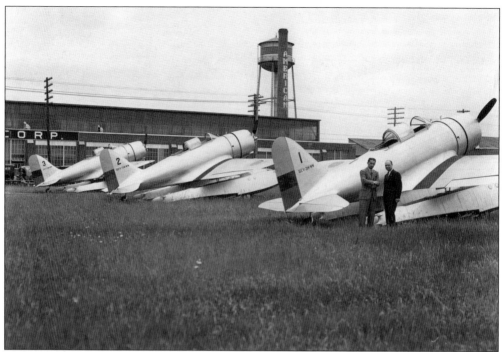

Major Seversky is standing next to three 3M-WW amphibians built for Colombia at the 127-acre Seversky Flying Field in front of the 1928 Fairchild Airplane factory. The word "American" is visible on the company smokestack, in reference to American Airplane, part of the Aviation Corporation conglomerate that acquired Fairchild Airplane in 1929. American folded in 1932. (Courtesy of Seversky Archives, LIRAHS.)

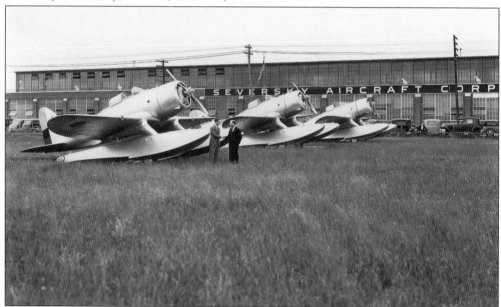

This is another photograph of the delivery of the three 3M-WW amphibian aircraft, featuring Seversky and a Colombian official. In this view, the main Seversky factory building can be seen. (Courtesy of Seversky Archives, LIRAHS.)

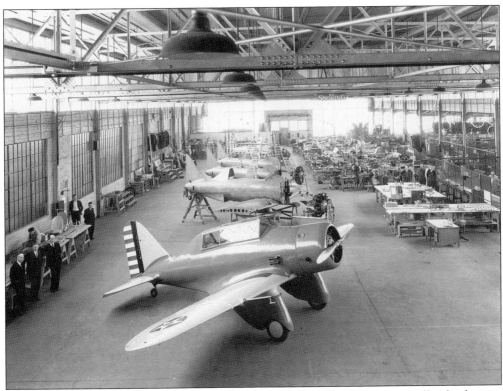

This is the inside of the Seversky final assembly area, with Seversky and company officials admiring the BT-8 basic trainer production line. (Courtesy of Seversky Archives, LIRAHS.)

The Seversky SEV-DS-1 aircraft was powered by a Wright Cyclone engine and is pictured on the Seversky Flying Field. The SEV DS-1 was built especially for Jimmy Doolittle, who was then a manager in the Shell Oil aviation division. DS was the designation for "Doolittle Special." (Courtesy of Seversky Archives, LIRAHS.)

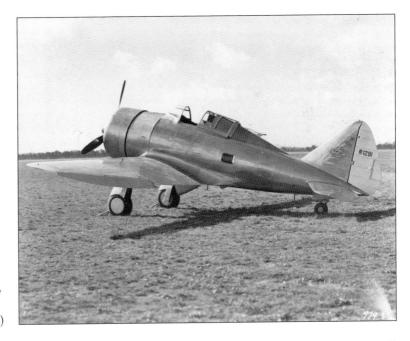

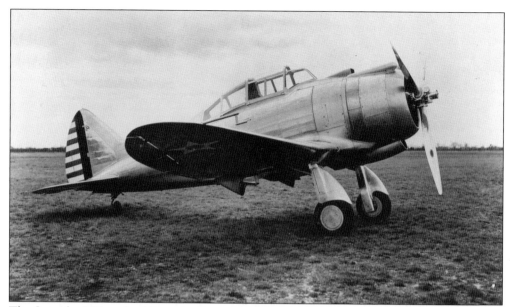

The Seversky P-35 evolved from the Seversky 1XP and 2XP designs, and a total of 77 all-metal P-35s were built. The aircraft featured retractable landing gear and was built in the Seversky Airplane factory located on Conklin Street in East Farmingdale in 1937–1938. Seversky tested the first P-35 on May 4, 1937. (Courtesy of Seversky Archives, LIRAHS.)

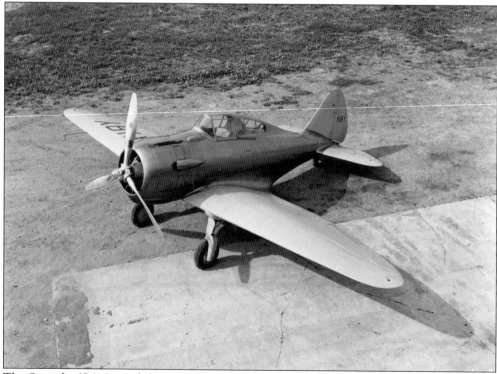

The Seversky 2PA-A amphibian "Convoy Fighter" was built in Farmingdale for export to the Soviet Union. Another 2PA-A model equipped with a fixed landing gear was also sold to the USSR. (Courtesy of Seversky Archives, LIRAHS.)

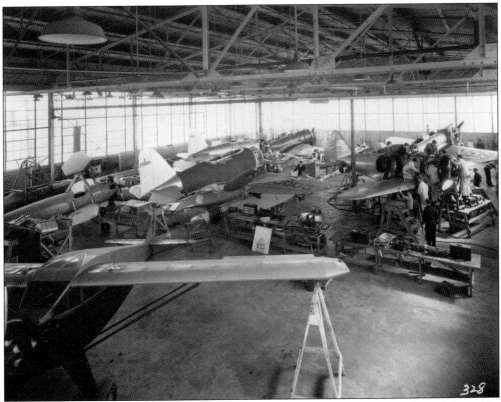

This 1936 photograph was taken inside the 1928 Fairchild hangar, which was purchased by Seversky in 1935. It shows the SEV-3M, all three SEV-3M-WWs, the Seversky 1XP, and private airplanes. The 1928 hangar is still in use at Republic Airport in Farmingdale. (Courtesy of Seversky Archives, LIRAHS.)

The Seversky NF-1 is pictured on the Seversky Flying Field in East Farmingdale on June 3, 1937. Seversky hoped to sell the NF-1 to the US Navy, but the Navy declined to purchase it. (Courtesy of Seversky Archives, LIRAHS.)

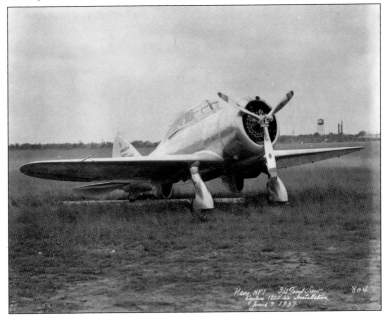

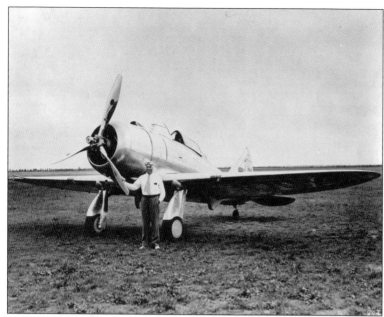

Frank Fuller Jr. won the 1937 and 1939 Bendix Races from Burbank, California, to Cleveland, Ohio, flying in his Seversky S2 racer, pictured. Described as "a demilitarized version of the Seversky P-35," it was powered by a 950-horsepower Pratt & Whitney R-1830 Twin Wasp engine. (Courtesy of Seversky Archives, LIRAHS.)

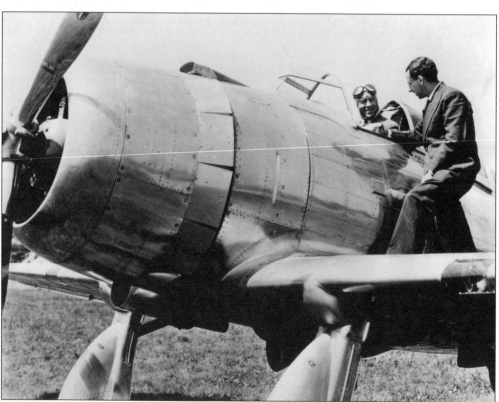

In 1937, Fuller won $9,000 flying the S2 from Burbank to Cleveland in seven hours, 54 minutes, 26.3 seconds at an average speed of 258.20 mph. In 1939, he flew the same course in seven hours, 14 minutes, 19 seconds at an average speed of 282.10 mph. Seversky is on the wing, with Fuller in the cockpit. (Courtesy of Republic Aviation Archives, LIRAHS.)

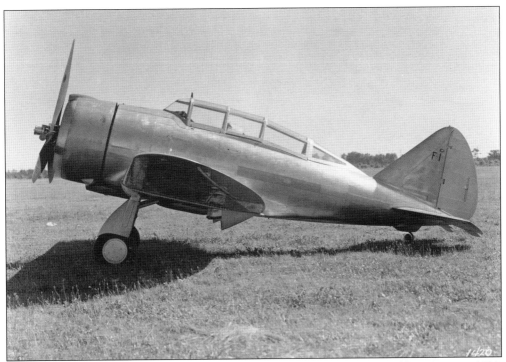

This Seversky 2PA-B3 was one of 20 Farmingdale-built 2PAs that were sold to Japan in 1938. (Courtesy of Seversky Archives, LIRAHS.)

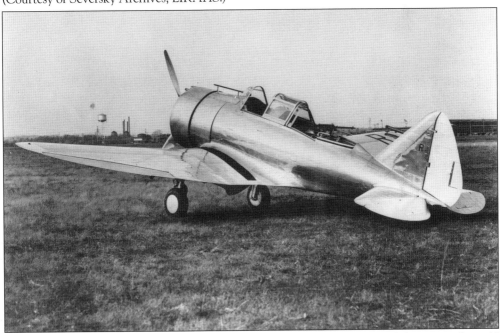

This is the Seversky 2PAL on the Seversky Flying Field in East Farmingdale. It was also sold to the USSR. Anger at Alexander Seversky by top US officials for selling aircraft to the Japanese and to Stalin's USSR contributed to his ouster in mid-1939. (Courtesy of Seversky Archives, LIRAHS.)

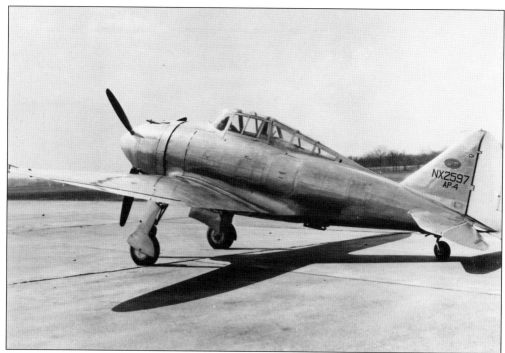

The Seversky AP-4 featured a flush-riveted skin and was designed by Alexander Kartveli as a high-altitude fighter. Powered by a Pratt & Whitney R-1830 Twin Wasp engine with a turbocharger, the AP-4 was first flown by Severksy test pilot Frank Sinclair on December 22, 1938. The US Army was impressed by the AP-4 during pursuit trials in 1939 and ordered 13 of the aircraft for testing. (Courtesy of CAM.)

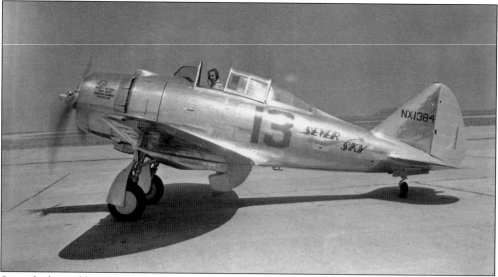

Seversky himself established a new east-west transcontinental speed record from New York to Los Angeles on August 29, 1938, in 10 hours and three minutes with this all-metal, low-wing AP-7. A week later, aviator Jacqueline Cochran won the 1938 Bendix Trophy Race flying this aircraft from Los Angeles to Cleveland in eight hours and 10 minutes at an average speed of 249 mph. (Courtesy of CAM.)

Seversky 2PA-B3s are pictured in the final assembly hangar. Twenty of these were built in Farmingdale and exported to Japan in 1938 as A8V1 convoy fighter aircraft. (Courtesy of Seversky Archives, LIRAHS.)

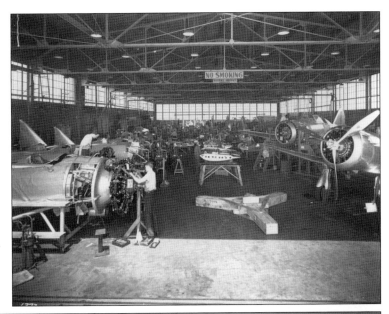

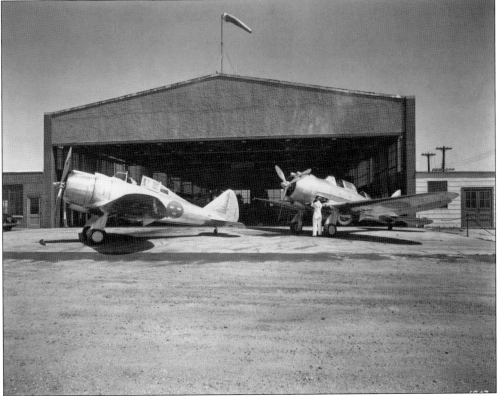

On the left is a Seversky/Republic EP1-106, and on the right is a Seversky/Republic 2PA-204A outside the company hangar. Sweden ordered 120 EP-1s (Export Pursuit) in 1939. Sixty EP1-106s and two 2PA-204As were delivered to Sweden, but 60 EP1-106 aircraft and 50 2PA-204As were seized by the United States in October 1940 and converted to trainers. (Courtesy of Seversky Archives, LIRAHS.)

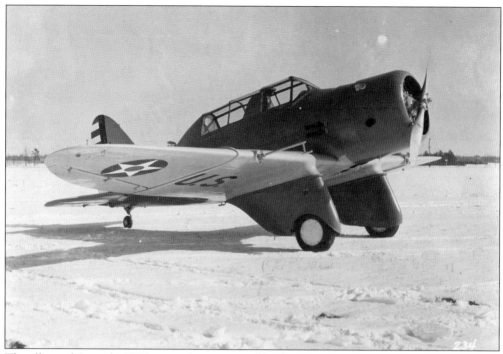

The all-metal Seversky BT-8 monoplane was used by the US Army Air Corps as a basic training aircraft. It was powered by a 400-horsepower Pratt & Whitney R-985-11 engine and was first test-flown by Alexander de Seversky in January 1936. Seversky delivered 35 BT-8s to the Army at an average cost of $25,086 in 1936. (Courtesy of Seversky Archives, LIRAHS.)

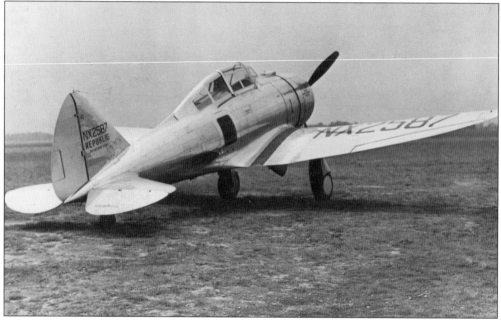

The Seversky EP-1-68 was first flown by test pilot George Burrell from the Seversky Airfield in Farmingdale in September 1938 and was sent to Europe for demonstration purposes in November of that same year. (Courtesy of Seversky Archives, LIRAHS.)

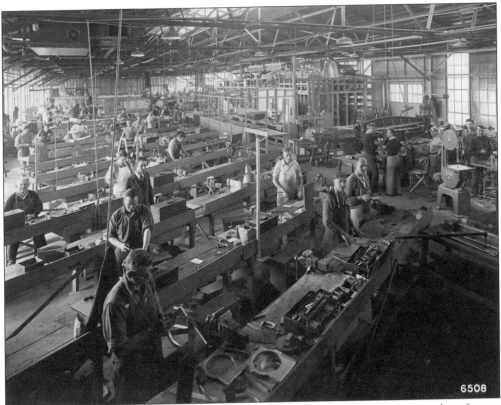

Charles B. Kirkham, engine and aircraft builder, moved into the idle American Airplane factory in East Farmingdale in 1933 and worked on Seversky 3M-WW aircraft. After Seversky moved into the factory, Kirkham relocated to the former Sperry/Fairchild factory on Motor Avenue in South Farmingdale in 1938, pictured here. (Courtesy of LIRAHS.)

Another interior photograph of the Kirkham factory in South Farmingdale taken around 1938 shows Kirkham's employees manufacturing gearboxes, vacuum cylinders, shock struts, propeller hubs, and more equipment for Grumman and other airplane manufacturers. (Courtesy of LIRAHS.)

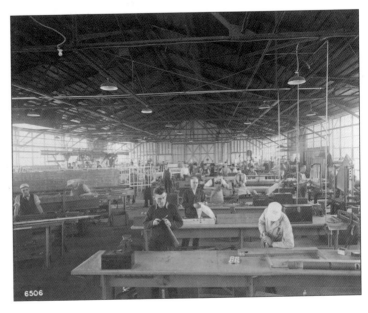

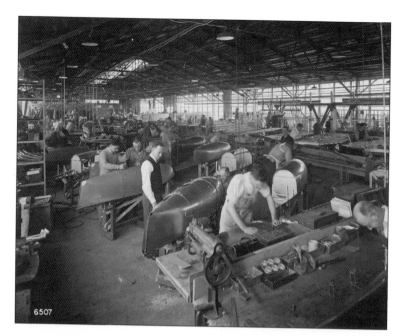

Kirkham workers are pictured fabricating structural airplane parts in the original Lawrence Sperry Airplane factory (1921–1923) and later the Sherman Fairchild Airplane factory (1926–1927) on Motor Avenue in South Farmingdale. (Courtesy of LIRAHS.)

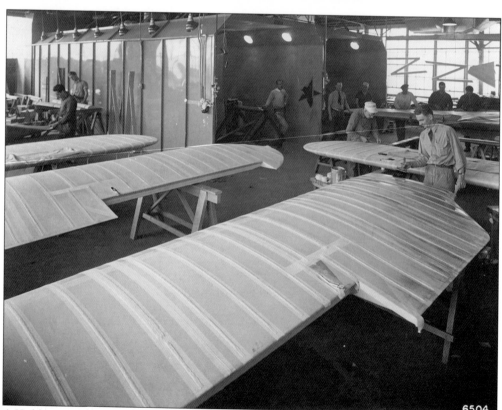

A Kirkham employee is painting or "doping" a wing structure at the Motor Avenue plant located at South Farmingdale in 1938. This process hardens and strengthens the wing fabric material. (Courtesy of LIRAHS.)

Three

AN ARSENAL OF DEMOCRACY
1939–1945

As the storm clouds of war darkened in Europe and Asia in the late 1930s, the US government moved quickly to stimulate the rapid production of military aircraft. This involved direct engagement by the government with many of the aircraft manufacturers located throughout the United States.

As head of Seversky Aircraft, the cash-strapped Alexander de Seversky had alienated top US Army Air Corps leaders by selling aircraft to the Soviet Union and Japan in the late 1930s. While Air Corps brass held Seversky's lead designer, Alexander Kartveli, in high regard, they did not believe that Seversky had the organizational or production skills to mass-produce quality aircraft. Seversky was removed in mid-1939, and the company was reorganized as the Republic Aviation Corporation. The United States financed the expansion of the Republic Aviation complex to permit the mass production of the Karvteli-designed P-47 Thunderbolt fighter-bomber.

Ground was broken for a one-million-square-foot factory with three assembly lines on January 6, 1941. The factory was built on what had been the Fairchild/Seversky Flying Field, and a larger, modernized testing field—featuring two new hangars, a control tower, and three concrete runways—was built just south of the new Republic factory. Republic was up to the task, with workers and engineers producing P-47 aircraft in incredible quantities—at a rate of seven aircraft per day. Meanwhile, engineers were working on improving the P-47 design and coming up with a number of variants, all of which led up to the P-47N model. Under the leadership of Ralph Damon and Alfred Marchev, Republic's tens of thousands of workers built 9,087 P-47s in Farmingdale between 1942 and 1945.

The US Navy expanded the Ranger Aircraft Engines factory in 1940 and again in 1942. Ranger now had its own hangar and space to produce thousands of airplane engines for the Army and Navy during World War II. To minimize driving, as gasoline and tires were rationed, the LIRR opened a Republic Station in 1941. New Highway was paved with concrete so that workers driving east into Suffolk County (many in carpools) could access the new Southern State Parkway.

Robert Simon, who had played a key role in aviation in Farmingdale since the 1920s, expanded the former Sperry/Fairchild factory in South Farmingdale as the Liberty Aircraft Finishing Corporation. Liberty did important subcontracting work for Grumman and Republic. World War II airplane manufacturing in Farmingdale-Bethpage gave a tremendous boost to the New York metro economy and facilitated the postwar suburbanization of Nassau County and western Suffolk County.

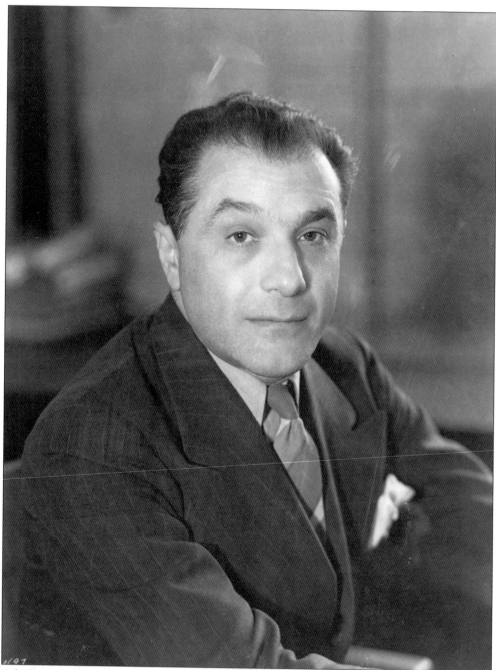

A brilliant Georgian émigré, Alexander Kartveli was the chief engineer for Seversky, Republic Aviation, and Fairchild Republic from 1931 to 1974. An innovative aircraft designer, Kartveli was the genius who led the development of the SEV-3, the P-35, the P-47, the XR-12 Rainbow, the F-84, and the F-105. He was also a consultant on the Fairchild Republic A-10 Warthog. With the Republic F-84, Kartveli led Republic Aviation out of the propeller era and into the jet age. (Courtesy of Republic Aviation Archives, CAM.)

On the night of May 16, 1938, the pictured US Army Air Corps B-18 medium bombers, based out of Mitchel Field in Long Island, "attacked" Farmingdale, New York, and Seversky Aircraft in the first blackout and air raid drill in the United States. The blackout and "bombing," broadcast live on national radio and covered by *Life* magazine, were declared successful. (CAM.)

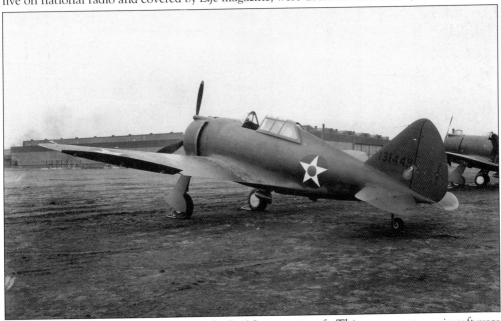

Beginning in 1939, Republic developed the P-43 Lancer aircraft. Thirteen prototype aircraft were delivered to the US Army in September 1940, followed by production of 272 P-43 aircraft, with half of these going to China. (Courtesy of Republic Aviation Archives, LIRAHS.)

This photograph shows the beginning of construction of Republic's 1943 final assembly hangar. The 1942 Republic hangar is at top left. (Courtesy of Republic Aviation Archives, LIRAHS.)

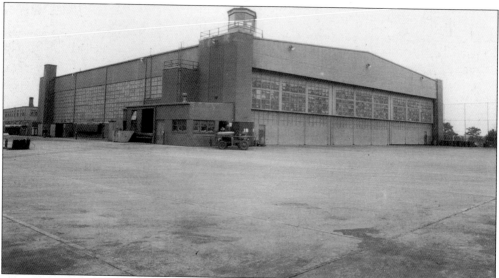

The Defense Plant Corporation finished building this final assembly hangar for Republic in 1942. Notice the control tower (Republic's first) on the southwest corner of the building. This historic hangar now houses the American Airpower Museum at Republic Airport. (Courtesy of Republic Aviation Archives, LIRAHS.)

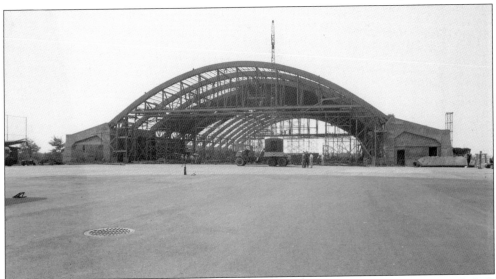

The 1943 Republic Aviation final assembly hangar building is nearing completion, with P-47 aircraft parked outside. This is now Hangar 4 at Republic Airport. (Courtesy of Republic Aviation Archives, LIRAHS.)

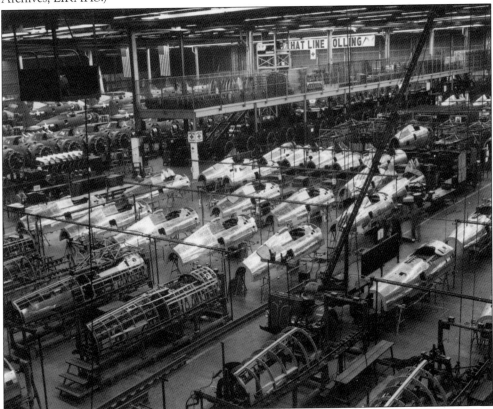

By 1944, the production line of the P-47 was massive. The foreground shows various unpainted P-47 fuselage assemblies, and in the background are the painted fuselage assemblies approaching final assembly. (Courtesy of Republic Aviation Archives, LIRAHS.)

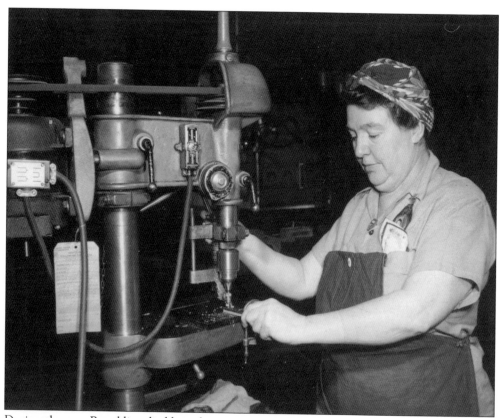

During the war, Republic relied heavily on women to work in the shop and in the subassembly areas for the building of P-47 aircraft. (Courtesy of Republic Aviation Archives, LIRAHS.)

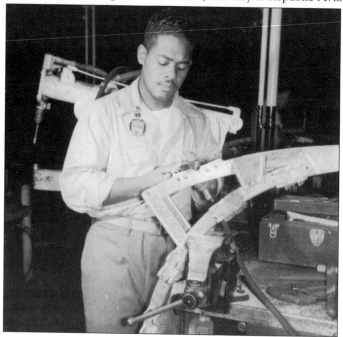

Republic Aviation had a racially integrated workforce in Farmingdale during World War II. Pictured is Jose Martialto, a skilled African American production worker who lived in nearby Wyandanch, working on a part for the P-47 Thunderbolt in 1945. (Courtesy of Republic Aviation Archives, LIRAHS.)

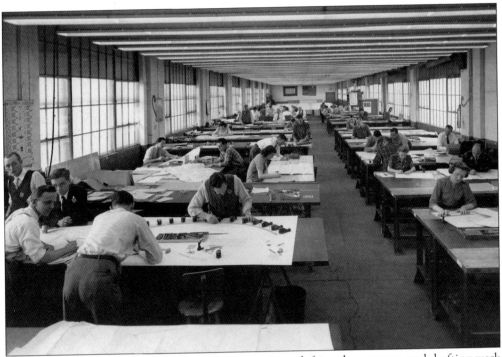

Republic Aviation's Building 5 housed the engineering, lofting department, and drafting work space for company engineers during World War II. From 1928 to 1941, Fairchild, American, Seversky, and Republic had all built aircraft in Building 5. (Courtesy of Republic Aviation Archives, Terry Alleg.)

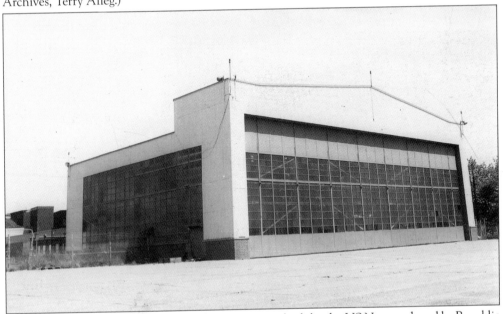

The 1942 Ranger Aircraft Engines service hangar was built by the US Navy and used by Republic Aviation after 1955. Fairchild Engine built the X-1 submarine in this hangar for the US Navy in 1954–1955. The hangar was razed in 1997 to expand the safety zone of the north end or Runway 1-19. It is the only historic hangar at Republic Airport that no longer exists. (Courtesy of LIRAHS.)

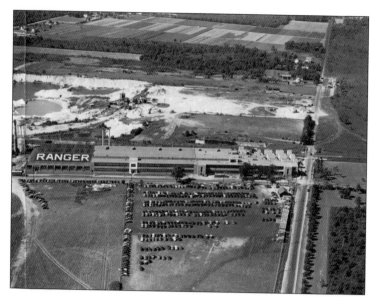

This is an aerial photograph of the Ranger Aircraft Engines factory complex in East Farmingdale in December 1941, just before the massive Republic Aviation factory was built to the left of the Ranger factory and just before the United States built a 160,000-square-foot addition and a hangar for Ranger in 1942. (Courtesy of Farmingdale Bethpage Historical Society.)

Just as women were brought in to replace men ages 18 to 45 who were serving in the armed forces, older men's services were also utilized to aid in the war effort. This photograph of Ranger Engines night shift workers shows the mixture of women and older men. Almost all these workers were replaced by younger men when the war ended and airplane production picked up again. John Douglas is standing fourth from the right in the back row. (Courtesy of Leroy Douglas.)

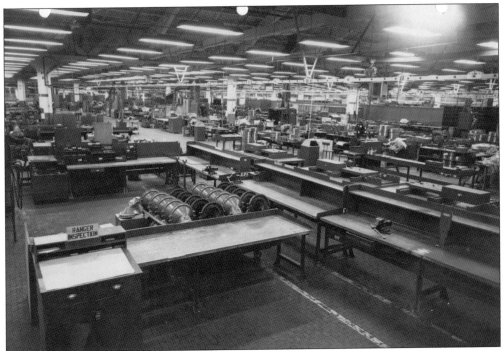

Engine manufacturing started with Fairchild's Caminez Engine Corporation in 1926 in South Farmingdale before it moved to East Farmingdale in 1928. After Aviation Corporation took it over in 1929, it was bought back by Fairchild in 1934 and renamed Ranger Aircraft Engines, as seen here. (Courtesy of NASM 9A12325.)

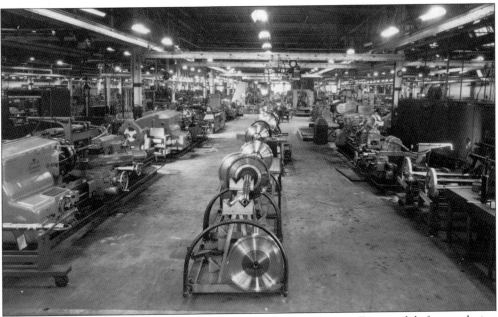

This is the main Ranger Aircraft Engines production area in the East Farmingdale factory during the war. Various internal components, such as the compressor section, are visible. (Courtesy of NASM 9A12343.)

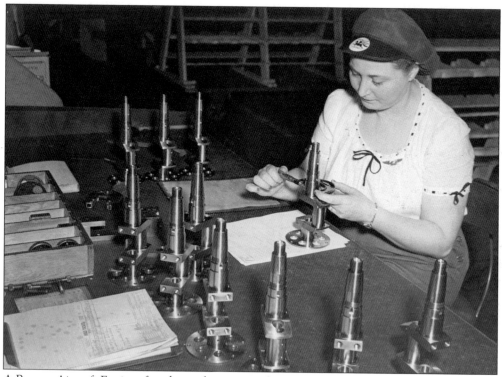

A Ranger Aircraft Engines female employee is conducting a precision inspection of an Andover crankshaft for a Ranger engine. Ranger and Republic Aviation employed many women as skilled production workers during World War II. This worker's hat features Ranger's Pegasus symbol. (Courtesy of NASM 9A12346.)

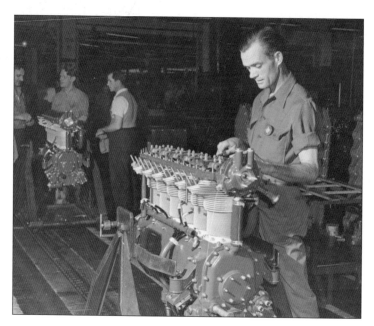

A highly skilled Ranger Aircraft Engines machinist assembles a Ranger Six in-line aircraft engine. The air-cooled, in-line, inverted six-cylinder L44 engine powered more than 6,500 aircraft during World War II. (Courtesy of NASM 9A12347.)

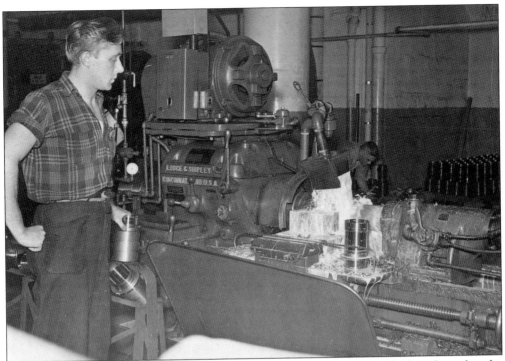

A skilled Ranger Aircraft Engines machinist uses a lathe to turn the cylinder barrels used in the Ranger engine at the East Farmingdale factory. (Courtesy of NASM 9A12349.)

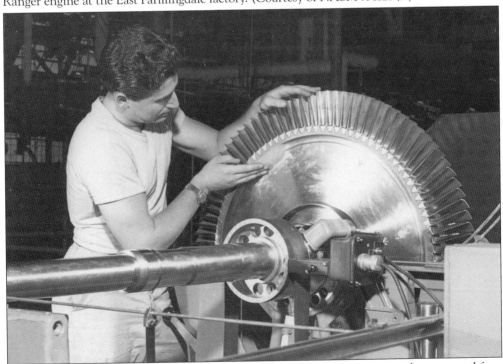

A Ranger Aircraft Engines employee is balancing a compressor component that was used for a Ranger aircraft engine. (Courtesy of NASM 9A12344.)

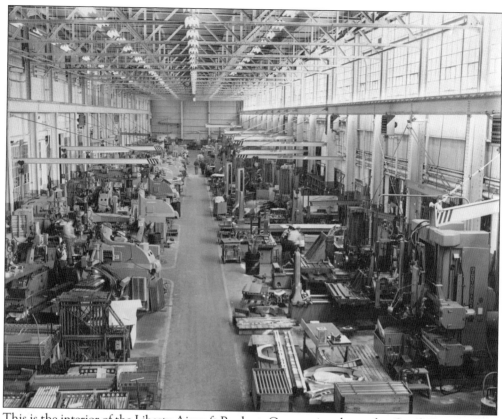

This is the interior of the Liberty Aircraft Products Corporation, located in South Farmingdale. Kirkham Engineering became Liberty Aircraft in 1939 under the leadership of Robert Simon, who had been factory manager and test pilot for Lawrence Sperry. He also managed production for Fairchild before working for Charles B. Kirkham. (Courtesy of Liberty Aircraft Products Corporation Archives, LIRAHS.)

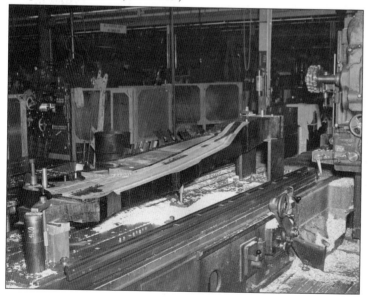

Production machinery is pictured inside the Liberty Aircraft Products Corporation. Liberty did major subcontracting for Grumman, Republic, and other airplane manufacturers. It won a prestigious Army-Navy "E" Production Award in October 1943. (Courtesy of Liberty Aircraft Products Corporation Archives, LIRAHS.)

This solid block of metal arrived from the Grumman Aircraft Engineering warehouse in nearby Bethpage, New York, and awaits milling by Liberty Aircraft workers. (Courtesy of Liberty Aircraft Products Corporation Archives.)

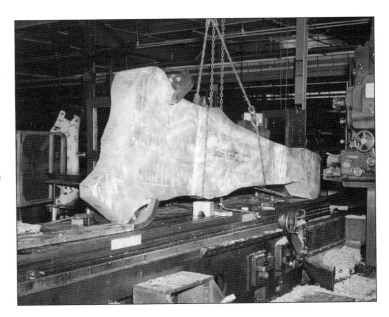

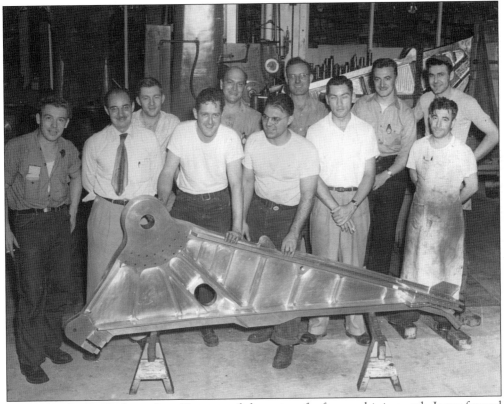

Pictured is the finished part for a Grumman fighter aircraft after machining work. It was formed from the solid block of metal shown in the previous photograph. (Courtesy of Liberty Aircraft Products Corporation Archives.)

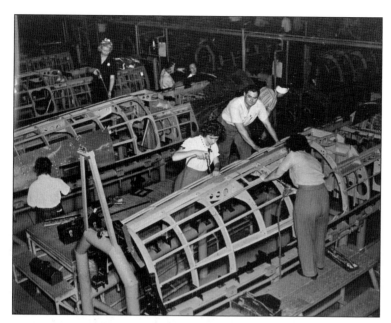

P-47 production at Republic Aviation during the war required the efforts of many female assembly line workers. (Courtesy of Republic Aviation Archives, LIRAHS.)

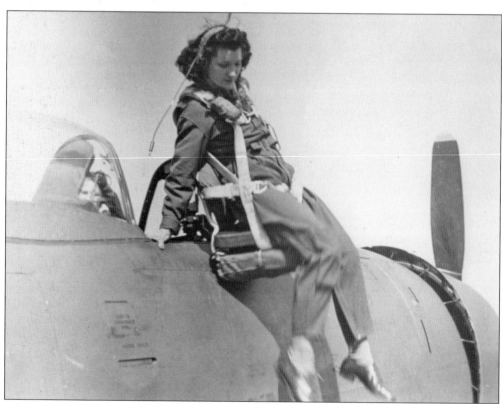

Teresa James was a Women Airforce Service Pilot (WASP) who ferried P-47s from Republic Aviation in Farmingdale to ports and to Army Air Force bases in 1943 and 1944. Her most famous flight was ferrying the *Ten Grand*—the 10,000th Republic P-47—from Farmingdale to Newark, New Jersey, on September 20, 1944, shortly before the WASPs were disbanded. (Courtesy of CAM.)

Republic Aviation in Farmingdale won three prestigious Army-Navy "E" awards during World War II. This award recognized the efforts of workers and companies that were outstanding in war production. Only five percent of eligible companies won the award during the war. (Courtesy of Republic Aviation Archives, Terry Alleg.)

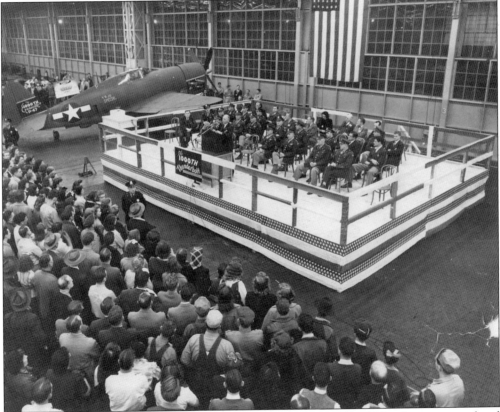

At this morale-boosting event, Republic Aviation president Alfred Marchev congratulated Evansville, Indiana, employees on the production of the 1,000th P-47 in Evansville on December 7, 1943. This plant built 6,242 P-47 aircraft during World War II. (Courtesy of Republic Aviation Archives, LIRAHS.)

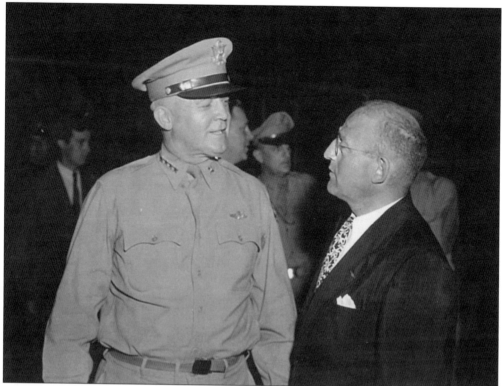

Gen. "Hap" Arnold is seen here with Republic president Alfred Marchev. Marchev and his predecessor before September 1943, Ralph Damon, directed the production of 15,329 P-47 aircraft in Farmingdale and Evansville, Indiana, during World War II. (Courtesy of LIRAHS archives.)

P-47 aircraft in formation are pictured in front of the 1942 Republic hangar, ready for shipment overseas after completing flight-testing. (Courtesy of Republic Aviation Archives, LIRAHS.)

The Republic Aviation XP-47B prototype first flew on May 6, 1941, piloted by Lowery Brabham from Republic to nearby Mitchel Field. It was the only P-47 built in 1941. The large, very heavy XP-47B was powered by a R-2800 Double Wasp engine, used a four-bladed pitch prop, and featured eight .50-caliber machine guns. (Courtesy of Republic Aviation Archives, LIRAHS.)

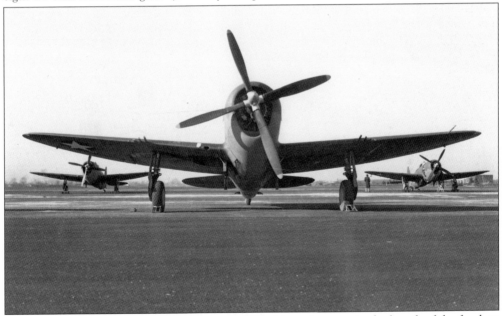

The P-47C was the same as the production P-47B, with an increase in the length of the fuselage by eight inches in order to incorporate a firewall extension on the forward end. The P-47C was the first Thunderbolt to be shipped to England for combat. (Courtesy of Republic Aviation Archives, LIRAHS.)

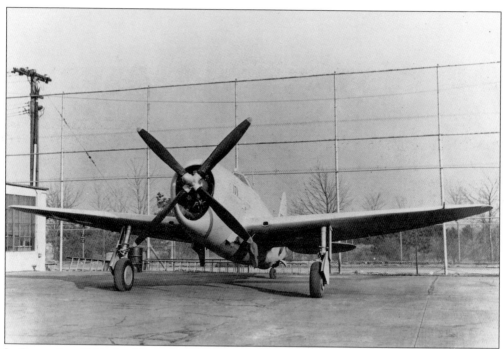

In September 1942, the 171st and last P-47B was developed into the XP-47E prototype, which used a hinged canopy and pressurized cockpit at high altitudes. Since P-47s were not used at high altitudes, the XP-47E did not go into production, but the experiment contributed to cabin pressurization designs for modern, high altitude aircraft. (Courtesy of Republic Aviation Archives, LIRAHS.)

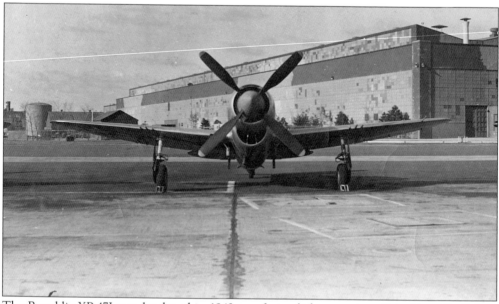

The Republic XP-47J was developed in 1943 as a faster, lighter version of the Republic P-47D. Only one prototype was produced. First flown on November 26, 1943, it used a 2,800-horsepower Pratt & Whitney engine. With a supercharger, the XP-47J reached a speed of 504 mph on August 5, 1944. (Courtesy of Republic Aviation Archives, LIRAHS.)

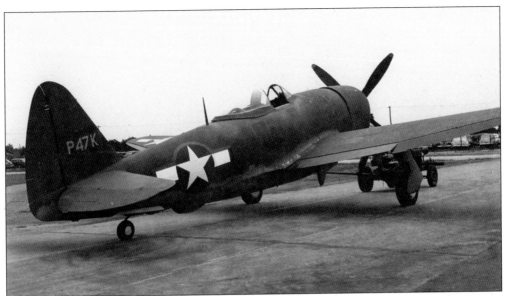

The Republic XP-47K was built as the first aircraft to utilize a bubble canopy. The prototype was completed in July 1943. The bubble canopy would be used in a later Thunderbolt model, the P-47N. (Courtesy of Republic Aviation Archives, LIRAHS.)

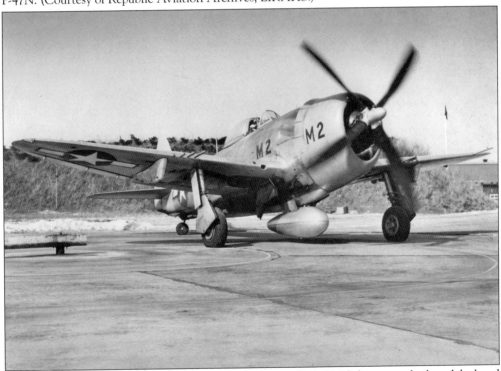

In Farmingdale, 130 of these high-performance, high-altitude P-47M fighters were built and deployed to the 56th Fighter Group in England. Powered by an R-2800 engine and a CH-5 turbocharger, the P-47M achieved level flight speeds of between 400 and 475 mph and allowed 56th Fighter Group pilots to destroy 15 German aircraft in combat. (Courtesy of Republic Aviation Archives, LIRAHS.)

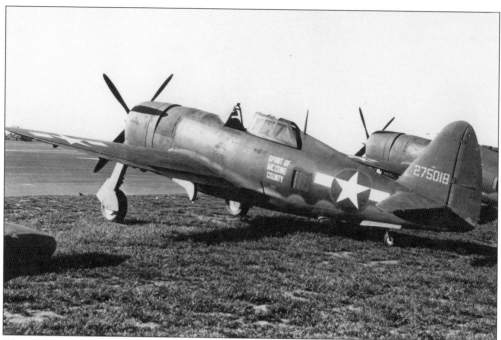

This P-47D-10RE on Republic Field is generally known as the "Razorback" because of its canopy design, which had good forward visibility for the pilot but limited visibility behind. This P-47, the *Spirit of McCone County*, was paid for by war bonds purchased by workers at the Fort Peck Dam in McCone County, Montana. (Courtesy of Republic Aviation Archives, LIRAHS.)

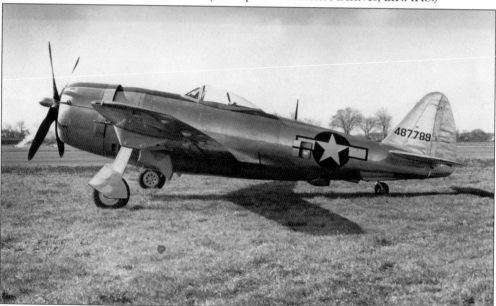

The last Thunderbolt version built, the P-47N, had a bubble canopy for improved visibility for the pilot. In 1944 and 1945, 1,667 were built for use in the Pacific. Equipped with fuel tanks in the wings as well as an external fuel tank, the heavy P-47Ns had a range of over 2,000 miles and were used to escort B-29 bombers and for ground and sea attacks in Japan. (Courtesy of Republic Aviation Archives, LIRAHS.)

To encourage civilian funding for building P-47 aircraft during the war, a "Racer" war bond program was developed. Pictured is Racer Thunderbolt No. 23, which was received by the Ninth Air Force, based in England in 1943. Republic service representative Bernard Kreuter is on the left, with servicemen Andrew Fortunato, Carmine Manganiello, and Thomas Cain. (Courtesy of Republic Aviation Archives, LIRAHS.)

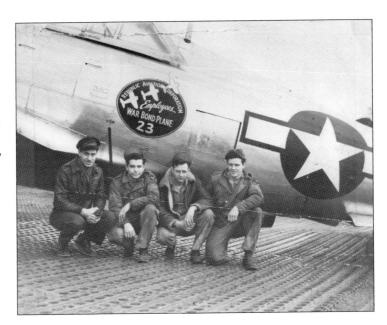

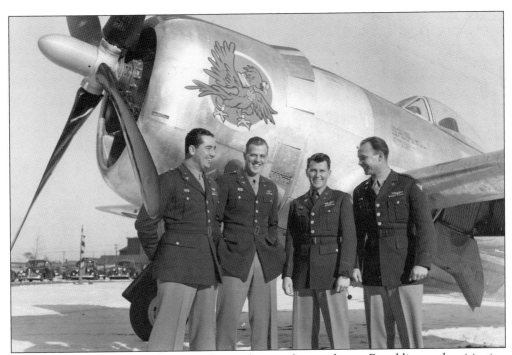

Another effort during the war to provide morale to civilian workers at Republic was the visitation of P-47 pilots to the facility. Pictured are pilots from the 65th Fighter Squadron, the Fighter Cock Squadron. From left to right are Capt. J. Ray Donahue, Lt. Alvan B. Wallian, Lt. S.R. Wilson, and Capt. James M. Eubanks. (Courtesy of Republic Aviation Archives, LIRAHS.)

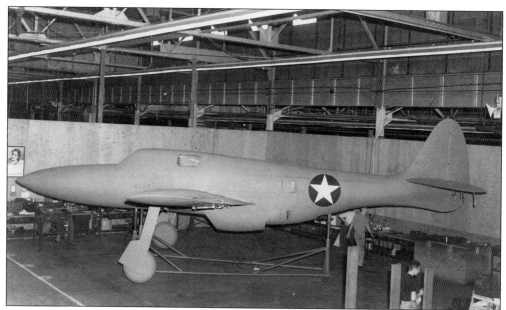

Republic engineers worked on new aircraft designs for the P-47. One of these designs was the XP-69, a mock-up of which is pictured. This design would only reach the mock-up stage, and the effort would be replaced by the XP-72 design. (Courtesy of Republic Aviation Archives, LIRAHS.)

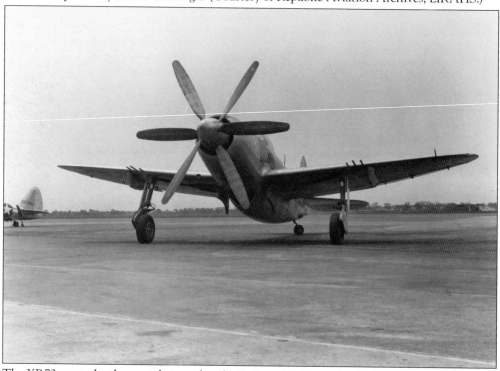

The XP-72 was to be the next design after the P-47, and it featured a dual-rotation propeller with a top speed of 504 mph. Two prototypes were built and flown in 1944; however, the program was halted because the Army Air Force preferred the P-47N. (Courtesy of Republic Aviation Archives, LIRAHS.)

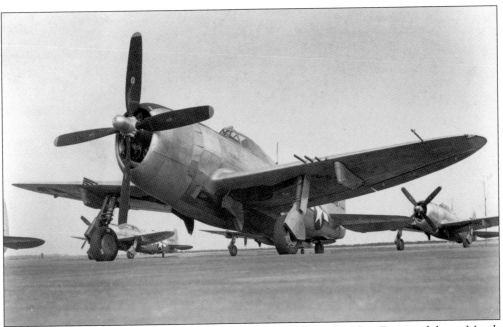

Republic P-47D-22RE aircraft are seen here at the Republic Airfield in Farmingdale on March 15, 1944. This is one of 9,087 P-47s that were built by Republic in Farmingdale between 1941 and 1945. (Courtesy of Republic Aviation Archives, LIRAHS.)

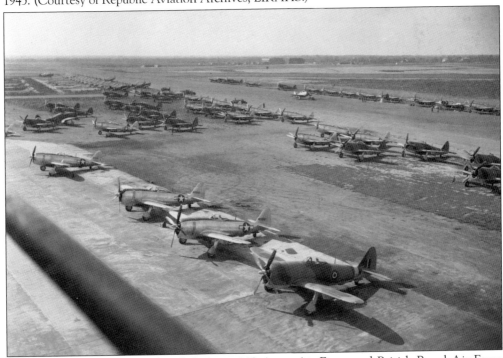

Republic Aviation P-47D Thunderbolts in US Army Air Force and British Royal Air Force markings are pictured at the Republic Airfield in Farmingdale on October 3, 1944. The Republic P-47 Thunderbolt "Jugs" were very successful as fighter-bombers in Europe during World War II. (Courtesy of Republic Aviation Archives, LIRAHS.)

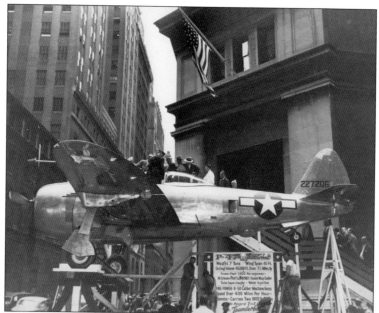

Another morale-boosting event during the war was a P-47 being trucked to Wall Street in downtown New York City as a static display to aid a war bond sales effort. (Courtesy of Republic Aviation Archives, LIRAHS.)

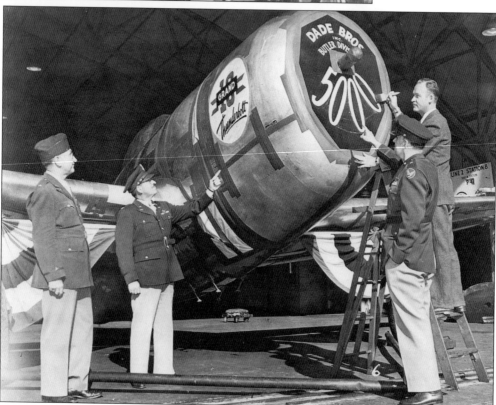

There was a ceremony in September 1944 at the Republic plant for the 10,000th P-47 aircraft that had been built. In addition, the Dade brothers, who prepared aircraft for overseas shipping, declared this aircraft the 5,000th P-47 shipped by the company. (Courtesy of Republic Aviation Archives, LIRAHS.)

World War II American ace Maj. Robert S. Johnson is greeted by thousands of Republic Aviation workers on June 9, 1944. Major Johnson shot down 27 German aircraft over France and Germany on 102 missions. He was chief test pilot at Republic after the war. (Courtesy of Republic Aviation Archives, LIRAHS.)

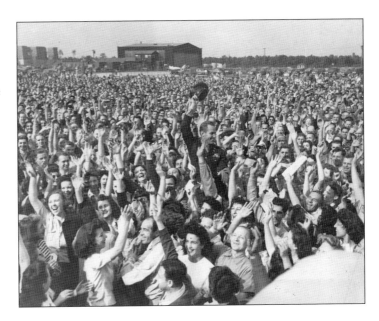

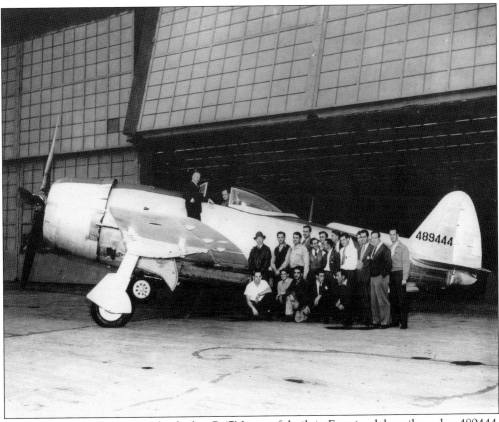

A ceremony was held in 1945 for the last P-47N aircraft built in Farmingdale, tail number 489444. This aircraft is currently on display at the Cradle of Aviation Museum in Garden City, Long Island. (Courtesy of Republic Aviation Archives, LIRAHS.)

REPUBLIC AVIATION CORPORATION

Farmingdale, New York

August 17, 1945

To: ENGINEERING DEPARTMENT

From: A. Marchev

With the capitulation of Japan our country has achieved total victory over its enemies. You have contributed a great share to the achievement of that total victory and we wish to extend to you the appreciation of your management for the cooperation and enthusiasm you have shown during the difficult war period.

The cessation of hostilities marks the beginning of a new period in which we will have to adjust ourselves and our operations to an entirely new set of circumstances. The tremendous energies displayed by industry in converting to war production several years ago must now be applied unabated to the conversion to peace-time economy if we are to avoid a dark period of non-production and un-employment. Engineering is the important initial step in such a program. Our engineering and design ability will carry the greatest share of the responsibility for the success of our company's future operations.

We are proud and happy to inform you that our immediate requirements call for the continued employment at Farmingdale of a total of over four thousand people. As our designs are completed that number will be increased. The A.A.F. is continuing our contracts for the XF-12, XP-84, YP-84 and P-84 airplanes. The P-47N airplane will continue to be produced in diminishing quantities until December of this year and the P-47Z will be produced in limited quantities from November until June, 1946. There also appears to be a good possibility that the Army will order a group of YF-12 airplanes. In addition, our management has already instructed us to proceed with all possible haste on both our two active commercial projects, the RC-2 and the RC-3.

The rest of the personnel in the factory will resume work on a five day, forty hour week schedule but in view of the above undiminished back-log of work for the Engineering Department and the extreme urgency for completing that work in a minimum amount of elapsed time it will be necessary for us, in Engineering, to continue to work our present hours until such time as we are able to build up a staff which will allow us to shorten our work week without jeopardizing our scheduled program. Since Engineering and Development, however, are the corner-stone upon which must be built our future manufacturing and sales operations our labors must continue with unchecked energy for the immediate months to come.

The government has rescinded the "Job Freeze Order" which restricted our freedom to change jobs during the war emergency. We are happy to see such quick evidence of the application of democratic principles for which the war was fought. Every American should be free to choose his type and place of work. We have much to do in Engineering and do not contemplate any reduction in our technical staff from lack of work. We are continuing to employ competent engineers.

Republic's secure and successful position in the aircraft industry, your future and the creation of jobs for many people in the days to come depend upon the efforts we now put forth in the Engineering Department. Your continued enthusiasm and voluntary cooperation are very necessary.

A. Marchev
President

This letter was addressed to Republic engineers a few days after V-J Day from the company's president, Alfred Marchev. The letter addresses both intermediate and long-term plans for the company. (Courtesy of Republic Aviation Archives, Terry Alleg.)

Four

THE JET ERA
1946–1964

When World War II ended in August 1945, Republic Aviation faced a crisis. The US government ceased funding the P-47 Thunderbolt, and thousands of workers were laid off—including almost all the female employees. Republic's president, Ralph Damon, tried but failed to diversify production with the XF-12 Rainbow high-speed photographic reconnaissance aircraft, the RC-2 (Republic Commercial) airliner version of the XF-12, and the RC-3 civilian amphibian. The Rainbow project did not develop beyond the prototype stage, and the RC-3 did not have much commercial success. Republic also built 1,200 JB-2 airframe drones in 1944–1945 that were derivatives of the infamous German V-2 rocket.

Once again, Alexander Kartveli and his team of engineers bailed out Republic. They designed Republic's debut jet fighter, the XP-84, which was first flown on September 6, 1945. The War Department funded production of Republic P-84B jets in 1947, and Republic's new president, Mundy Peale, organized the mass production of the straight-wing F-84 Thunderjet, thus greatly bolstering the workforce in Farmingdale. By the end of 1950, 15,000 people were employed at Republic. The F-84s provided effective service in the Korean War as escorts and ground attack aircraft.

In 1950, Republic began developing the larger, more powerful, swept-wing F-84-F Thunderstreak fighter-bomber, which was first test-flown on November 22, 1952. Although plagued by production delays, the F-84-F and the RF-84-F Thunderflash were used by the US Air Force and NATO nations. Republic built 4,457 Thunderjets, 2,111 Thunderstreaks, and 715 Thunderflashes in Farmingdale. The F-84-F program required the extension of Runway 14-32 at Republic, which was completed in 1954.

In the early 1950s, Alexander Kartveli developed the powerful Republic F-105 Thunderchief for the US Air Force, which was intended to carry a nuclear weapon long distances to its target. The YF-105A made its test flight on October 22, 1955. The 833 F-105s that were built in Farmingdale were used extensively as an attack bomber in the Vietnam War. The missions were dangerous and resulted in a significant loss of aircraft—to the point that F-105D squadrons had to be deactivated.

From 1947 until 1998, BH Aircraft built components for jet turbines and rocket engines in its factory on Eastern Parkway in Farmingdale.

The F-105 program was a major program for Republic, but it alone was not enough to keep the company viable. Several other projects were proposed, but finances became a major problem for the Republic Aviation Company by the beginning of the 1960s.

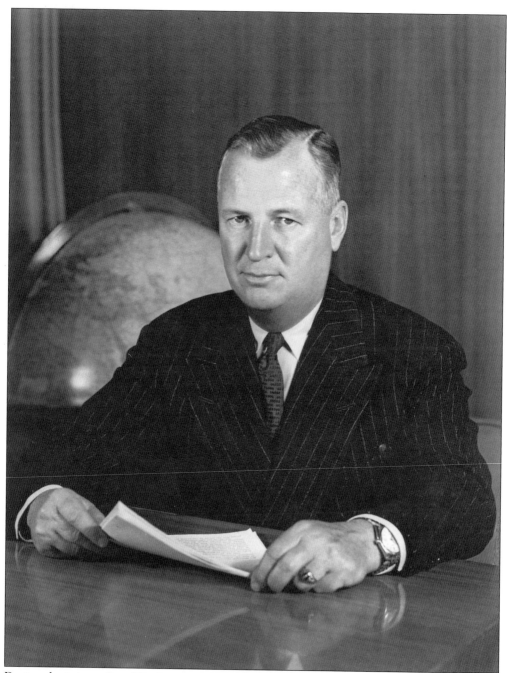

During the jet age, Republic Aviation was guided by Mundy Peale. Peale started at Republic in 1939 and worked his way up to general manager of the Evansville plant, which turned out over 6,000 P-47 aircraft during World War II. He became president of Republic in Farmingdale in January 1947, replacing Alfred Marchev, and served through 1965. (Courtesy of Republic Aviation Archives, LIRAHS.)

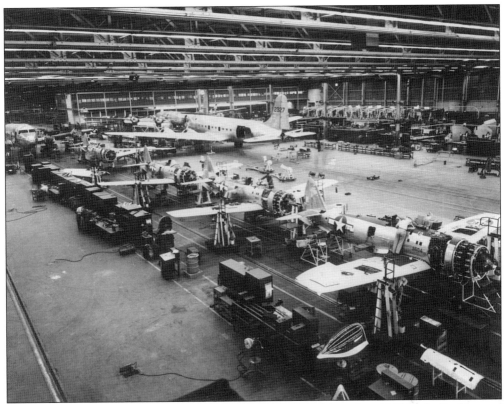

The last produced P-47N is on the final assembly line at Republic in late 1945. In the background are two of the 50 C-54 transports under construction. The end of the war brought a sudden and massive termination of P-47 contracts and a major reduction in the workforce. (Courtesy of Republic Aviation Archives, LIRAHS.)

At the end of World War II, with P-47 production ending, Republic developed the XF-12 Rainbow photographic reconnaissance aircraft for the US Army, which is pictured next to a P-47. The Rainbow program ended with two prototypes built. (Courtesy of Republic Aviation Archives, LIRAHS.)

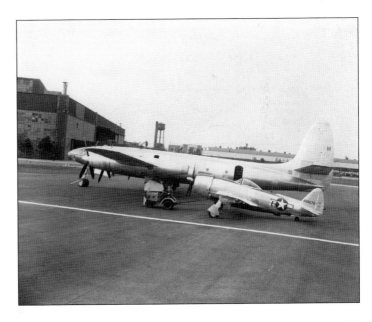

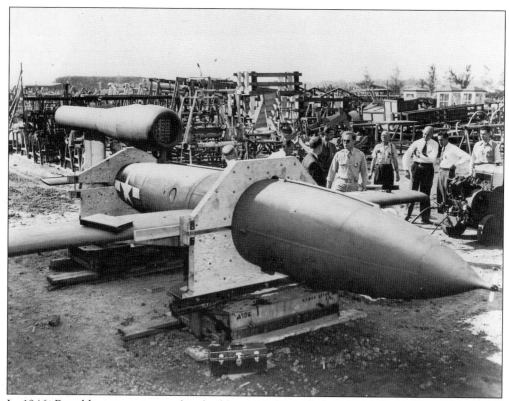

In 1946, Republic was contracted to build a guided missile based on the German V-2 missile used near the end of World War II. This missile was called the JB-2 Loon. (Courtesy of Republic Aviation Archives, CAM.)

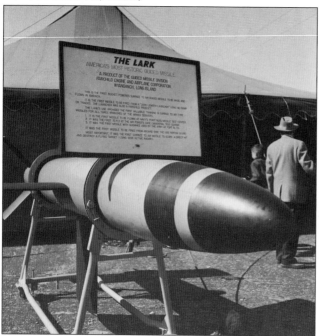

Guided missiles were a big field in the mid-1950s. Another Long Island company, Fairchild Guided Missile Division, which was located in nearby Wyandanch, built the Lark missile for the US Navy. Fairchild would later merge with Republic in 1965. (Courtesy of Ken Neubeck.)

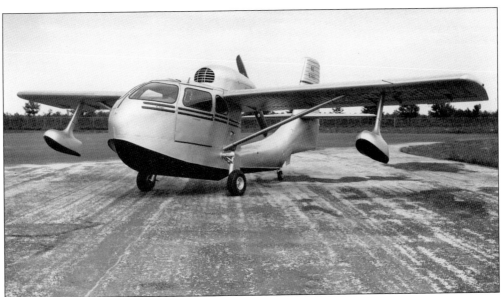

At the end of World War II, Republic anticipated a large postwar demand for civilian aircraft and came up with the RC-3 Seabee aircraft in late 1945. The design used fewer components to help reduce costs. (Courtesy of Republic Aviation Archives, LIRAHS.)

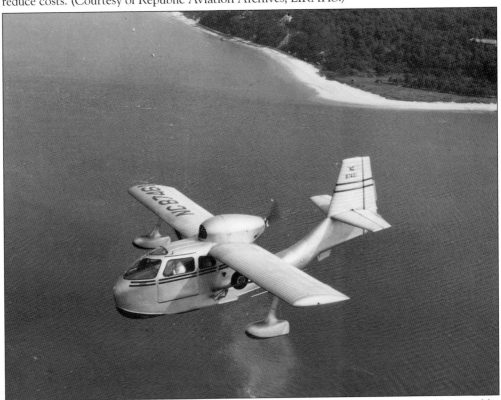

However, by 1947, sales for the Seabee stalled completely, and production was stopped by Republic with a final total of 1,060 Seabees built—some of which are still flying today. (Courtesy of Republic Aviation Archives, LIRAHS.)

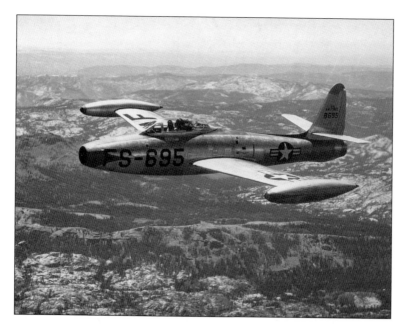

In 1948, Republic officially entered the jet age with the F-84 Thunderjet. The initial models—the F-84B and F-84C—had some structural issues that caused them to be withdrawn from active duty by 1952. The F-84D, pictured, had improvements in performance, and 154 were built. (Photograph by the United States Air Force; LIRAHS.)

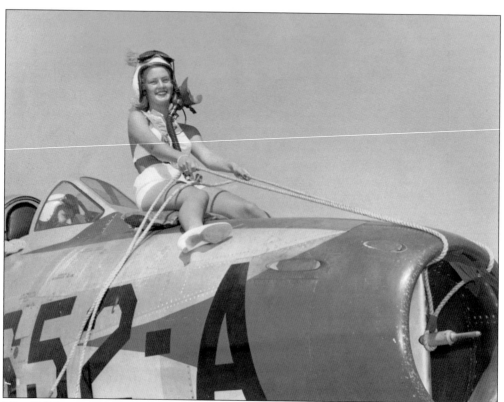

Miss California of 1949 is seen here on an F-84 in a publicity photograph after being named Miss Thunderjet of 1949 by pilots of the 82nd Fighter Squadron based at Hamilton Field in California. (Courtesy of LIRAHS; photograph by the United States Air Force.)

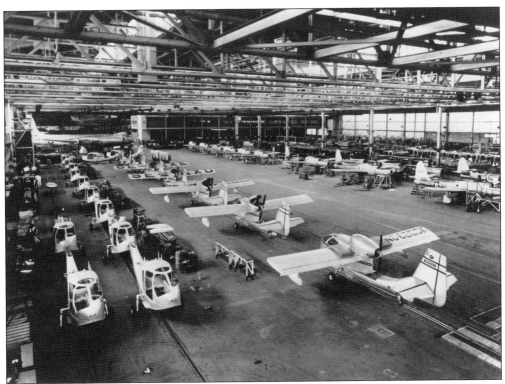

The Republic final assembly line in 1946 shows the RC-3 Seabee in production on the left and the F-84 Thunderjet on the right. (Courtesy of Republic Aviation Archives, LIRAHS.)

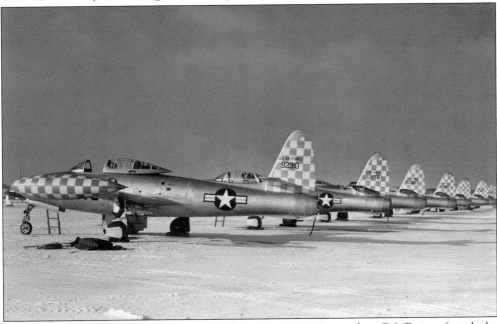

The F-84E model was vastly improved over the earlier F-84F. Pictured are F-84E aircraft with the 86th Fighter-Bomber Wing stationed at the Neubiberg Air Base in Germany. A total of 843 F-84E aircraft were built. (Courtesy of LIRAHS; photograph by the United States Air Force.)

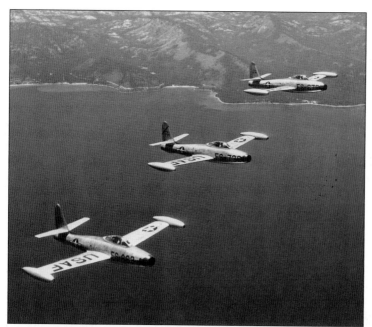

The F-84D and the F-84E Thunderjets were the US Air Force's primary strike aircraft during the Korean war. These aircraft were flown on over 86,400 missions, destroying 60 percent of all ground targets during the war alongside eight Soviet-built MIG fighters. Pictured are three F-84Ds from the 78th Fighter Group soaring over Lake Tahoe. (Courtesy of LIRAHS; photograph by the United States Air Force.)

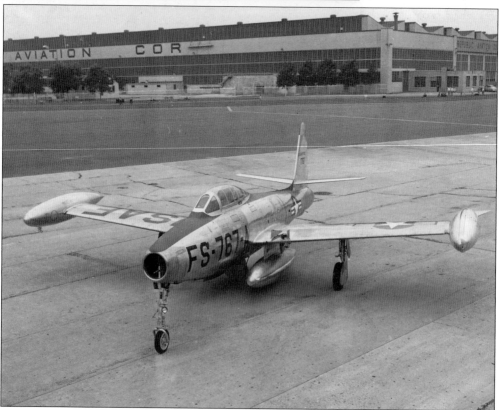

The F-84G would be the definitive model, of which 3,025 aircraft were built. This version was introduced in 1951, and featured an in-flight refueling receptacle located in the left wing. Used by NATO, the aircraft saw war action in Angola in 1961. (Courtesy of LIRAHS.)

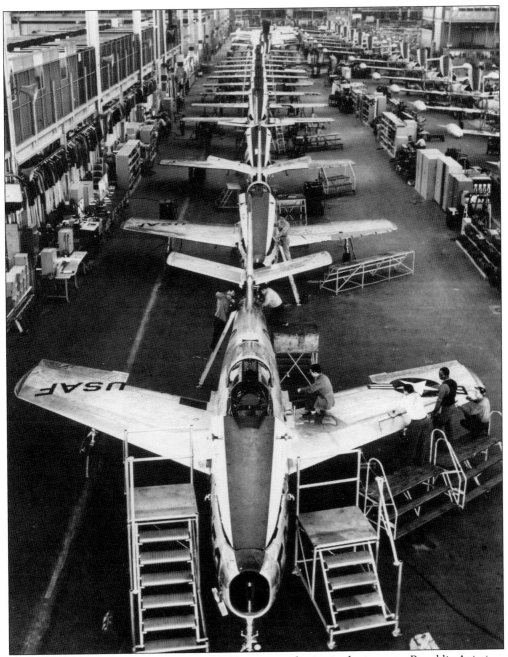

As seen in this photograph taken around 1952, a new era begins in the jet age at Republic Aviation. In the final production line, there is a transition from the straight-wing F-84G Thunderjet aircraft (right) to the newer, swept-wing F-84 Thunderstreak (center). (Courtesy of Republic Aviation Archives, LIRAHS.)

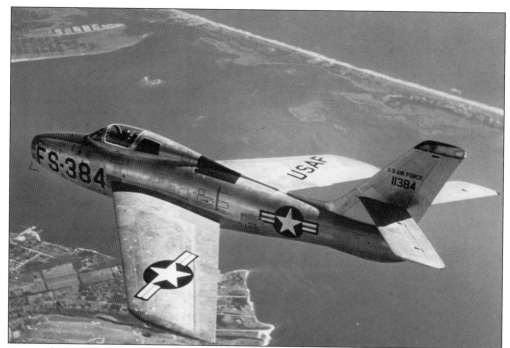

From the Thunderjet design, Republic developed its first swept-wing aircraft, the F-84F Thunderstreak. Over 2,700 were built, but none saw combat with the US Air Force. (Courtesy of Republic Aviation Archives, LIRAHS.)

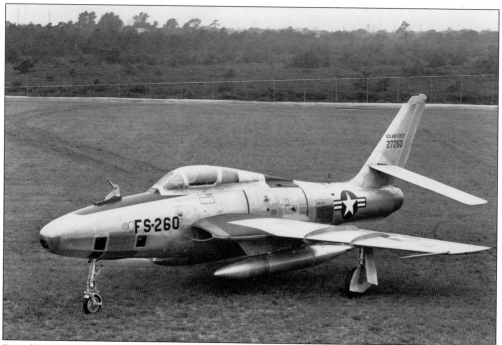

Republic also developed a reconnaissance version from the Thunderstreak design that was designated the RF-84F Thunderflash. This aircraft featured various cameras located in the nose. A total of 715 RF-84Fs were built. (Courtesy of Republic Aviation Archives, LIRAHS.)

The US Air Force looked at using bomber aircraft to carry fighter aircraft. Project Tip Tow included two F-84 Thunderjets being towed on the ends of the wings of a B-29 bomber. During the last test flight in April 25, 1953, one of the fighters came off wrong, crashing into the bomber and killing the F-84 pilot and five B-29 crew members. (Courtesy of Republic Aviation Archives, CAM.)

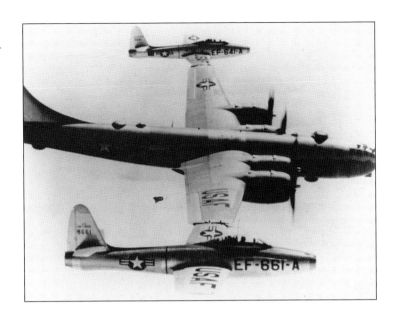

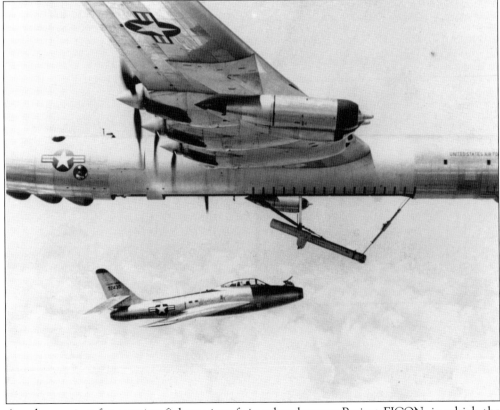

Another project for carrying fighter aircraft in a bomber was Project FICON, in which the aircraft was carried in the belly of a B-36 bomber. Republic aircraft, such as the F-84F and the RF-84F, were used during testing until the program ended in 1956. (Courtesy of Republic Aviation Archives, CAM.)

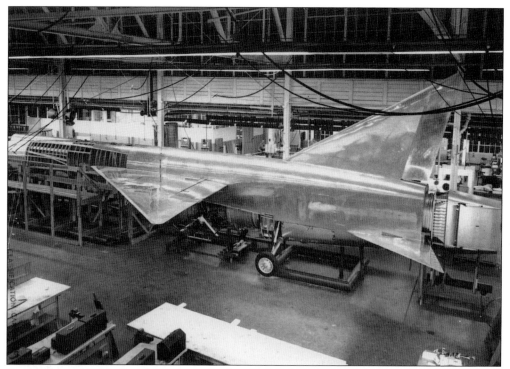

During the mid-1950s, Republic was involved in the development of a Mach 3 fighter made entirely of titanium. The aircraft was designated the F-103 and featured a cockpit capsule that could be ejected. This mock-up was built prior to the program being cancelled. (Courtesy of Republic Aviation Archives, LIRAHS.)

The International Association of Machinists (IAM) union shop at Republic Aviation launched a strike in February 1956 that lasted over three months after wage increase demands were denied. There were incidents of violence during picketing, as pictured here. The strike ended in June with minor wage concessions. (Courtesy of Republic Aviation Archives, Peter Zuzulo.)

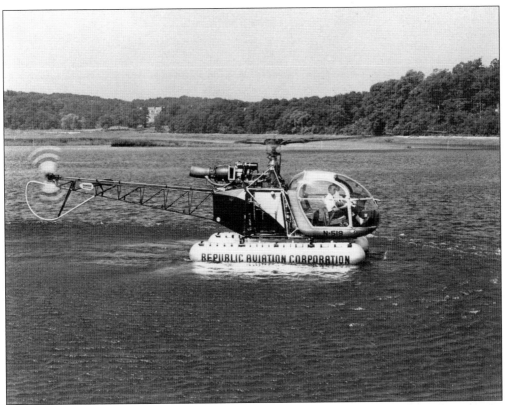

In 1957, Republic opened a helicopter division and was a manufacturer of a French helicopter, the Alouette II. Some helicopters were sold to local police agencies, but overall, sales were marginal. (Courtesy of Republic Aviation Archives, LIRAHS.)

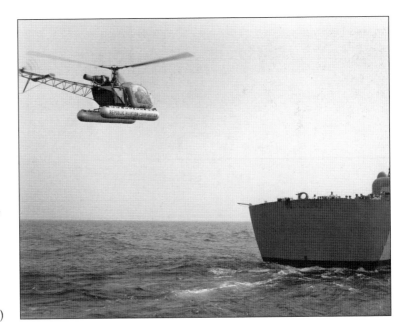

A Republic-built Alouette II is undergoing sea trials with US Navy destroyer USS Mitscher in the late 1950s. No military orders developed. (Courtesy of Republic Aviation Archives, LIRAHS.)

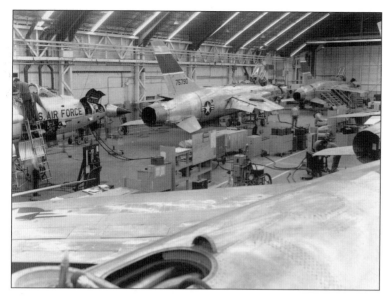

This is the final assembly area in the Republic plant for the F-105B aircraft, seen around 1958. A total of 71 aircraft for the B model were built by Republic. The F-105D was the next model built by Republic, and it featured several changes from the B model. (Courtesy of Republic Aviation Archives, CAM.)

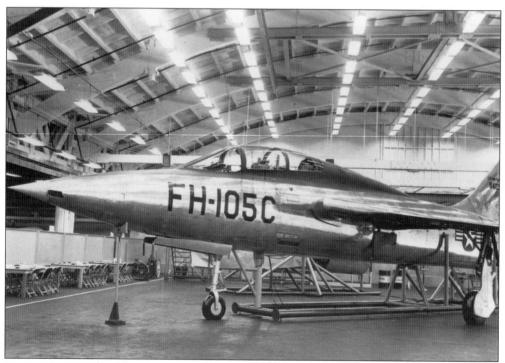

During the F-105B production contract, Republic began working on a two-seat trainer version of the aircraft, which was designated the F-105C, with a mock-up made. However, the company was not able to generate interest by the US Air Force to go further into production. Later, the F-105F became the two-seat model produced for the US Air Force. (Courtesy of Republic Aviation Archives, CAM.)

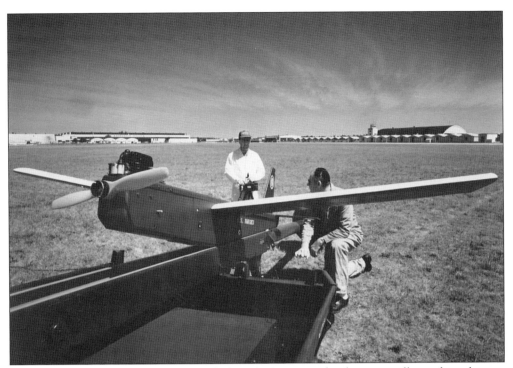

Beginning in 1959, Republic worked with the US Marines to develop a surveillance drone known as the Bikini drone, which was equipped with a 70 mm camera. After seven years of research, it was determined that the technology at the time could not support such a program, although years later, the RQ-7 Shadow UAV was developed from some of the techniques originally developed for the Bikini. (Courtesy of Republic Aviation Archives, LIRAHS.)

In 1963, Republic unveiled a design known as the "Flying Crane," which was an aircraft that could carry a 29-foot long cargo container weighing up to 40,000 pounds. The aircraft design featured two rotatable vertical thrust engines. This did not reach the prototype stage. (Courtesy of Republic Aviation Archives, LIRAHS.)

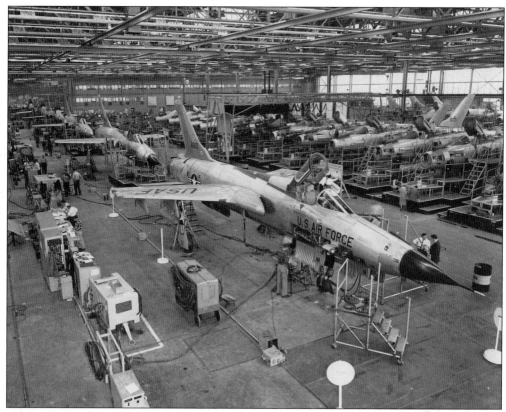

This is the final assembly area in Republic during the peak of F-105D production around 1961. The D model was the most produced of the F-105 models. (Courtesy of Republic Aviation Archives, CAM.)

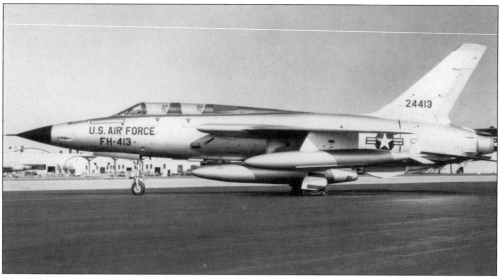

The F-105F was the actual model that was selected by the US Air Force, later followed by an F-105G two-seat version. This F-105F is undergoing flight-testing at Republic Airfield. (Courtesy of Republic Aviation Archives, CAM.)

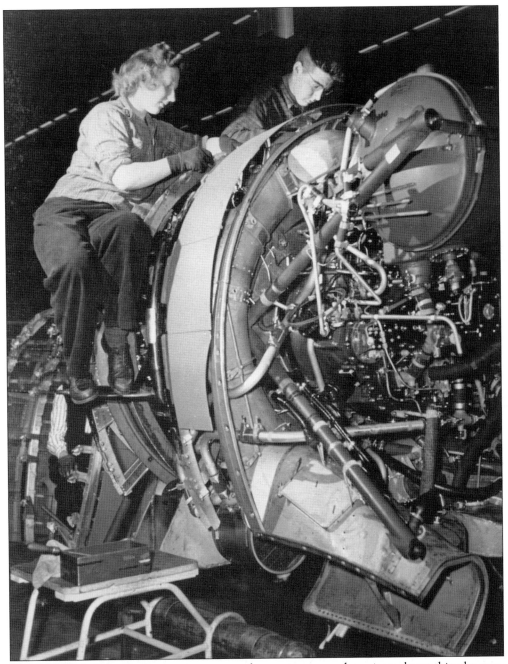

The F-105 had various radar components, such as antennas and receivers, located in the nose section of the aircraft. During World War II P-47 production, Republic continued to employ women workers throughout the company, including on the assembly line pictured here. (Courtesy of Republic Aviation Archives, LIRAHS.)

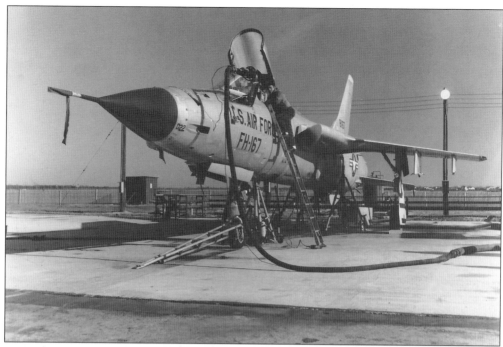

An early F-105D aircraft is undergoing refueling tests in 1960 at the Republic Airfield facility. The aircraft is being refueled through the in-flight fuel probe located in the nose section. A total of 610 D Model F-105 aircraft were built for the US Air Force. (Courtesy of Republic Aviation Archives, CAM.)

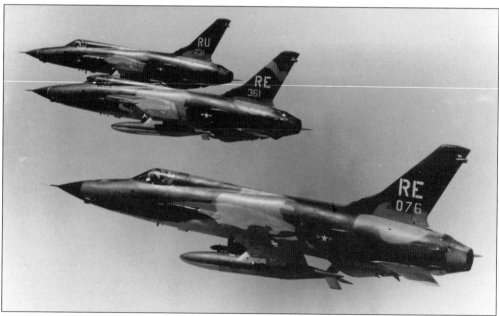

The F-105D Thunderchief was the workhorse for the US Air Force during the Vietnam War. Pictured are three F-105D aircraft from the 44th TFS and the 357th TFS in 1970. The aircraft suffered tremendous losses conducting bombing raids over North Vietnam to the point that the squadrons flying the D model became non-operational. (Courtesy of Republic Aviation Archives, CAM.)

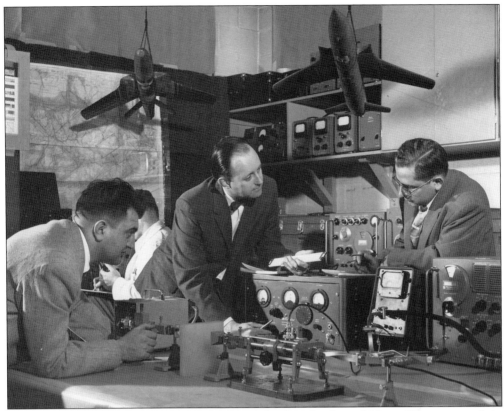

From left to right, Republic engineers Peter Zuzolo, Don Brady, and Harry Weinstein work in the antenna lab in the late 1950s. There are F-84F and F-105 models hanging from the ceiling, along with a map on the wall that indicates flight-test patterns of the RF84F and F-84F for the APW-11 and ARD-9 radar-evading system tests against MSQ-1 radar at Griffis AFB in Rome, New York. (Courtesy of Republic Aviation Archives, Peter Zuzolo.)

The antenna lab building at Republic features a radar horn, which is pointed at the F-84F model mounted on the roof of the second building. Antenna patterns were determined through this type of testing. (Courtesy of Republic Aviation Archives, Peter Zuzolo.)

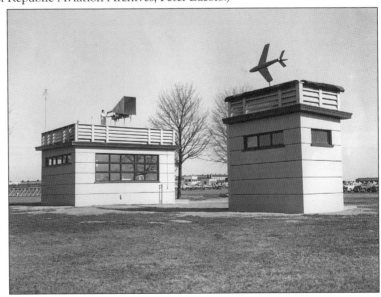

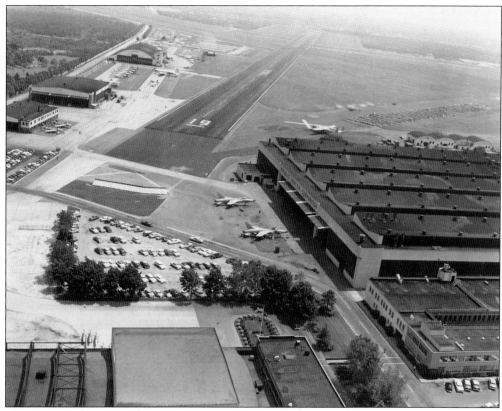

This is the Republic Company plant layout during peak activity in June 1960. In the right foreground are two F-105D aircraft outside the Building 17 hangar doors. In the center is a Fairchild C-119 Boxcar aircraft, and to the left in the lower hangar are F-84F aircraft. (Courtesy of Republic Aviation Archives, LIRAHS.)

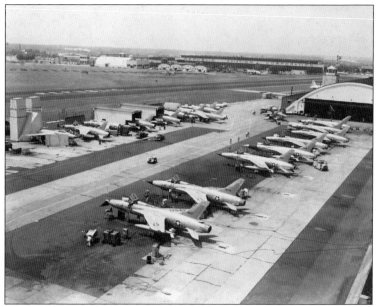

This is another view of the Republic Aircraft facility in June 1960. In the foreground to the right are F-105D aircraft on the flight line. To the left are F-105D aircraft that are undergoing engine testing with baffle buildings. (Courtesy of Republic Aviation Archives, LIRAHS.)

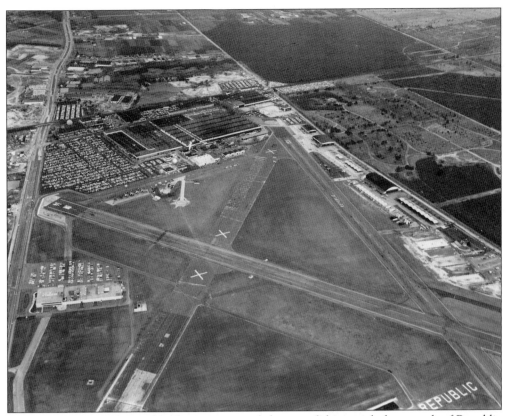

Republic Aviation's factory buildings are toward the top of this aerial photograph of Republic Airfield taken in the early 1960s. (Courtesy of Republic Aviation Archives, LIRAHS.)

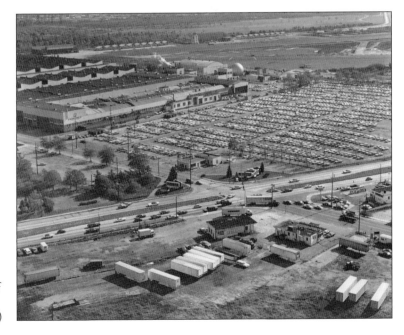

This is the Fairchild Republic building at the end of the 1960s, with a view of the main employee parking field (Lot 6) at Route 110 and Conklin Street. (Courtesy of Republic Aviation Archives, LIRAHS.)

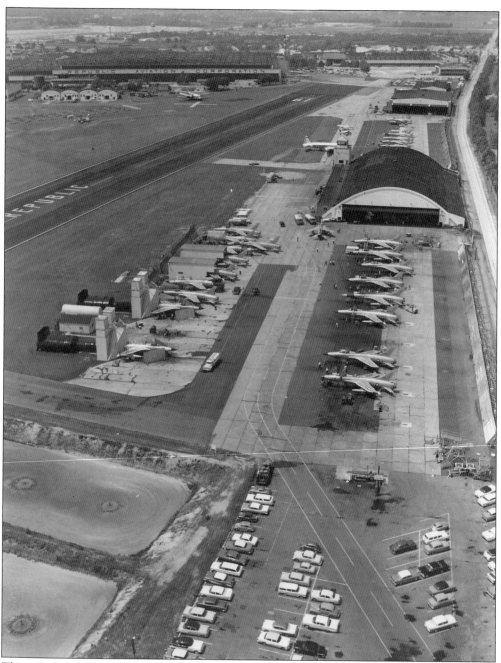

This aerial photograph of the Republic Aviation Corporation and the airfield in 1960 shows the many buildings owned by the company. The main plant can be seen in the background, while in the foreground is the final run-up test in front of the 1943 hangar, which housed Republic's traffic control tower (1943–1983). The 1928 and 1942 Ranger hangars are seen in the background. (Courtesy of Republic Aviation Archives, LIRAHS.)

Five

FINAL YEARS OF AIRCRAFT MANUFACTURING
1965–1987

Sherman Fairchild, who started airplane manufacture in East Farmingdale, returned in 1965 and purchased Republic, renaming it the Fairchild Hiller Division of the Fairchild Corporation. Fairchild Hiller floundered in the late 1960s in Farmingdale as the company tried but failed to win contracts for a VTOL fighter and for the new F-15 fighter.

During this time, the company survived by winning subcontracts for the tail sections of the McDonnell F-4 Phantom fighter and the Grumman F-14 Tomcat and for wing control sections of the Boeing 747. In addition, the company was awarded a contract by NASA to build the vertical tail sections for the space shuttle. In the meantime, Fairchild Republic worked on a proposal for a close air support aircraft. After a competitive flyoff with two prototypes, the US Air Force announced in 1973 that Fairchild Republic had been selected to develop and build the A-10 close air support aircraft. The early A-10s were built in Farmingdale, but then just the wings and fuselages were built in Farmingdale, with final assembly and flight-testing at the Fairchild factory in Hagerstown, Maryland. In all, Fairchild built 733 A-10s.

After 1980, Fairchild Republic tried but failed to successfully build the twin-engine, 34-seat SF-340 short-haul turboprop airliner in a joint venture with Saab of Sweden. Fairchild Republic encountered major production problems with the SF-340 and lost money on the program. Fairchild Republic then won a contract in July 1982 to build the T-46A Next Generation Trainer (NGT) for the US Air Force. By 1985, Fairchild had encountered expensive development costs with the NGT T-46A and experienced delays in meeting program milestones, including having an incomplete aircraft at the official rollout.

With the company experiencing major financial problems in 1986–1987 and with the loss of support for the T-46A program in Congress, Fairchild terminated both the SF-340 program and T-46A production after building only four aircraft. Thus, by the fall of 1987, seventy years of airplane manufacturing in Farmingdale ended with employment and economic loss to the community and the New York metropolitan area. The future of the site remained uncertain, and it would be a number of years before the property was developed for new companies.

Despite the loss of the company, its products stayed in service on the space shuttle and the 747. More importantly, the A-10 Thunderbolt performed well in Operation Desert Storm in 1991 in taking out Iraqi armor and conducting rescue missions during the war. The A-10 has been used heavily in several war operations since that time, up to the present.

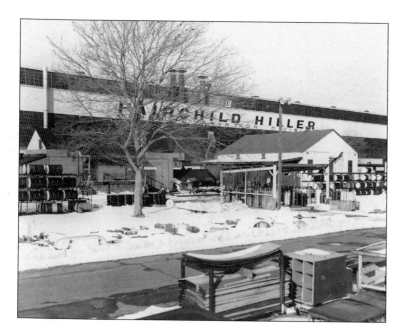

In 1965, Fairchild Hiller bought Republic Aviation. Pictured is the new signage on the main building. (Courtesy of Fairchild Republic Archives, LIRAHS.)

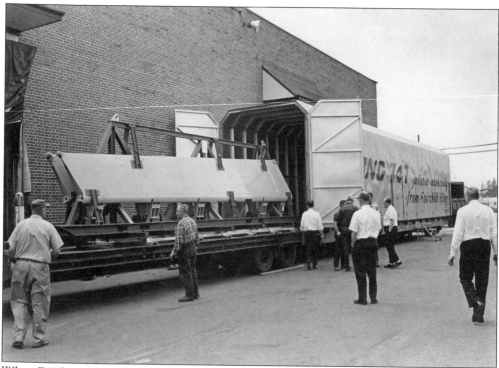

When F-105 production ended by the late 1960s, Fairchild Republic did not have a prime contract in-house and found various subcontract work to keep the shop busy, such as building various wing surfaces for the Boeing 747, which were shipped by rail to Seattle. (Courtesy of Fairchild Republic Archives, LIRAHS.)

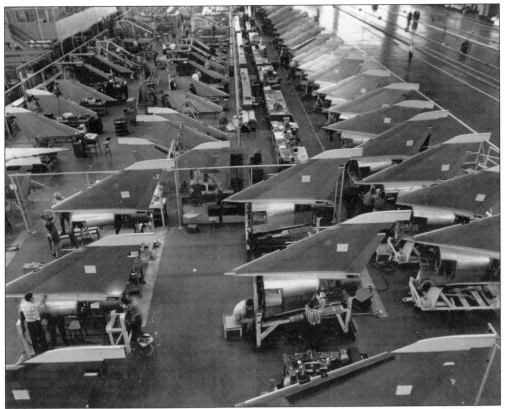

Another important subcontract for the company that kept Fairchild Republic in business was the building of tail sections for the F-4 Phantom for McDonnell Douglas Company. (Courtesy of Fairchild Republic Aviation Archives, LIRAHS.)

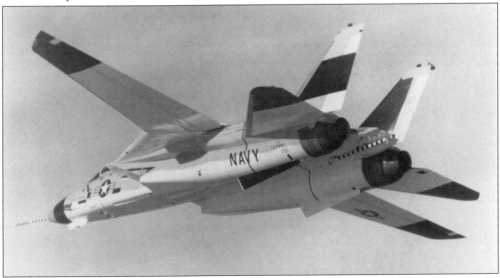

In addition to the F-4 tail subassembly work, Fairchild received work to build the tail fins for the Grumman F-14 Tomcat during the 1970s. (Courtesy of Fairchild Republic Aviation Archives, LIRAHS.)

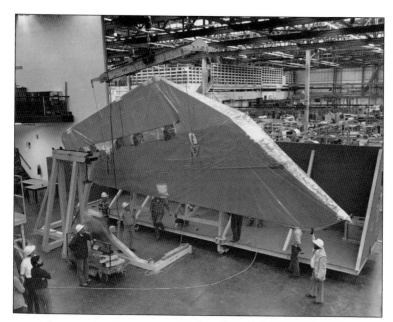

In the 1970s, Fairchild Republic was contracted by NASA to build all the space shuttle tails, which were constructed entirely in the Farmingdale facility and shipped to California. (Courtesy of Fairchild Republic Archives, LIRAHS.)

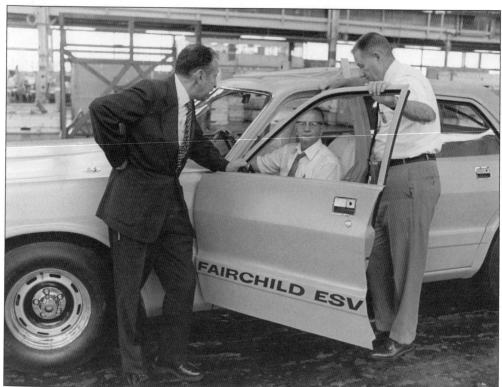

As defense work wound down, Fairchild Republic looked to get into commercial products such as the Experimental Safety Vehicle program run by the US Department of Transportation. The project was headed by project engineer George Hildebrand (right), and the company delivered two prototypes in 1972 for testing various safety issues. There was no follow-on work. (Courtesy of Fairchild Republic Archives, CAM.)

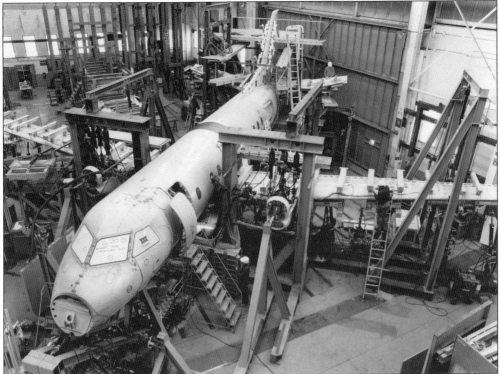

In 1980, Fairchild Republic entered into a partnership with Saab in Sweden to build sections of the short-range commercial SF-340 aircraft. Fatigue testing was conducted at Farmingdale, as seen here. Fairchild withdrew from the project in 1984. (Courtesy of Fairchild Republic Archives, CAM.)

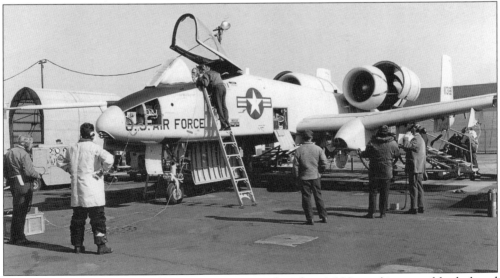

By 1970, the Fairchild Republic Company was reduced to 1,000 employees and had placed its hope in the new A-X aircraft for the US Air Force. Fairchild Republic had to make two prototypes—given the aircraft designation A-10—to compete in a flyoff. Here, the first A-10 prototype undergoes engine runs at the Farmingdale facility. (Courtesy of Fairchild Republic Aviation Archives, LIRAHS.)

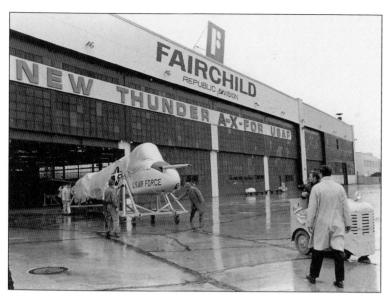

The first A-10 prototype is prepared by employees in early 1972 for aerial shipment from Farmingdale to Edwards Air Force Base in California in order to participate in the flyoff competition with the A-9 aircraft made by the Northrop Company. A large sign indicates the A-X competition. (Courtesy of Fairchild Republic Archives, CAM.)

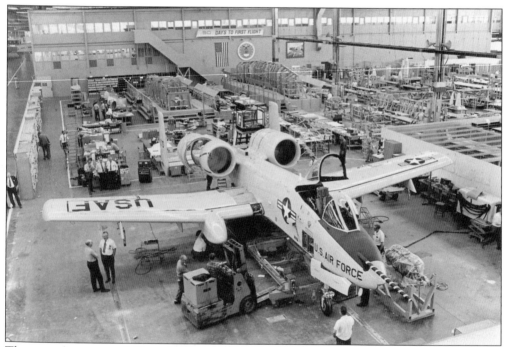

The second prototype A-10 was built in the company facility in Farmingdale in 1972. On January 18, 1973, Fairchild Republic was announced as the winner of the flyoff competition. A major reason for picking the A-10 was that the prototype was more representative of a production aircraft. (Courtesy of Fairchild Republic Archives, CAM.)

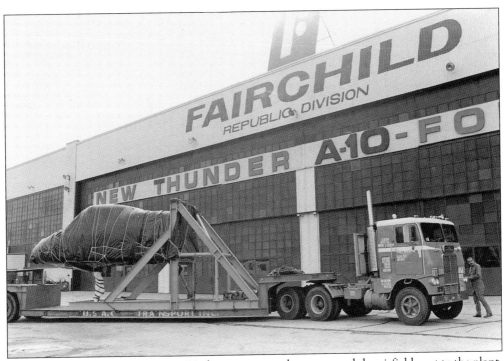

When A-10 production began in 1974, the company no longer owned the airfield next to the plant. Fuselage and wing subassemblies would be completed in the Farmingdale facility and then trucked to the company in Hagerstown, Maryland, for final assembly and flight-testing. The company sign outside the final assembly doors has been changed to indicate the A-10 name. (Courtesy of Fairchild Republic Archives, CAM.)

The A-10 had what was known as a titanium "bathtub," which surrounded the pilot and the cockpit area. This additional protection prevented ground fire from entering into the cockpit. (Courtesy of Fairchild Republic Archives, CAM.)

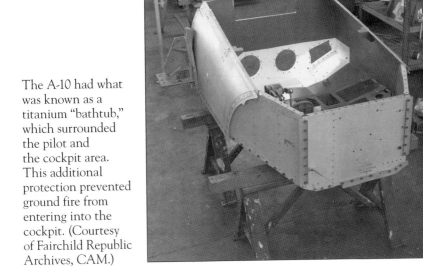

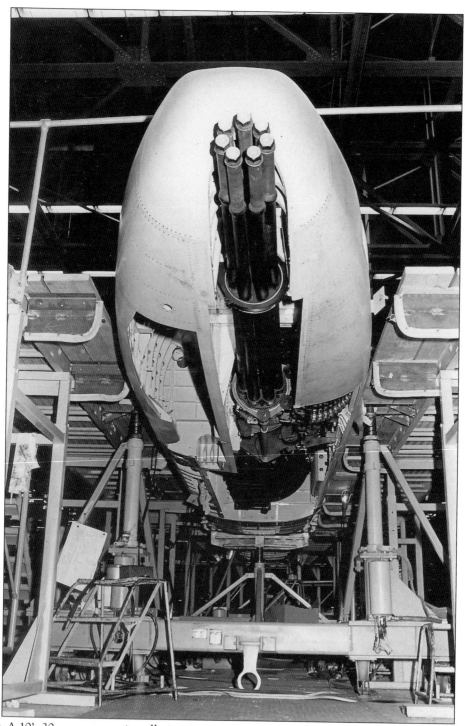

The A-10's 30 mm cannon installation is massive, consuming much of the space in the lower front nose section. Located after the muzzle plate are the seven long barrels, followed by a feed mechanism and the large ammo drum located below the cockpit. (Courtesy of Fairchild Republic Archives, CAM.)

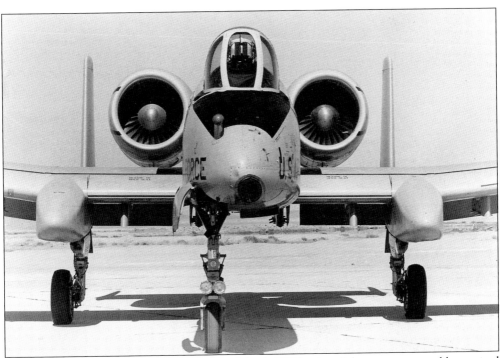

This photograph shows the unique features of the A-10. The size of the cannon assembly required the nose landing gear to be offset from the center, and the high mounting of the two engines help protect them from ground fire. This early prototype is fitted with a 20 mm cannon due to the unavailability of the 30 mm gun at the time. (Courtesy of Fairchild Republic Archives, CAM.)

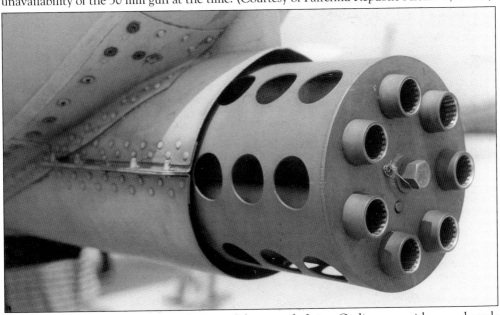

The A-10's gun is the most telling feature of the aircraft. It is a Gatling gun with seven barrels capable of firing seventy 30 mm shells a second, effective in penetrating the armor of tanks. The A-10 was originally designed to counteract the tanks of the Warsaw Pact in Europe in the 1980s. (Courtesy of Ken Neubeck.)

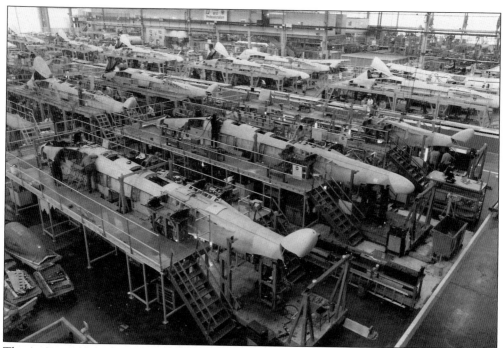

The A-10 production line reached a peak of 13 aircraft a month by the early 1980s. The area around the final fuselage assembly line was called Broadway. A total of 713 production A-10 aircraft were built from 1974 to 1984. (Courtesy of Fairchild Republic Archives, CAM.)

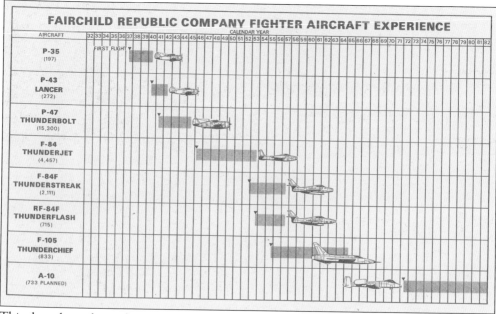

FAIRCHILD REPUBLIC COMPANY FIGHTER AIRCRAFT EXPERIENCE

This chart shows the production schedule for various prime contract programs at Fairchild Republic. The A-10 was the last major program, with 733 aircraft originally planned. However, the number was finally cut to 713. (Courtesy of Fairchild Republic Archives, CAM.)

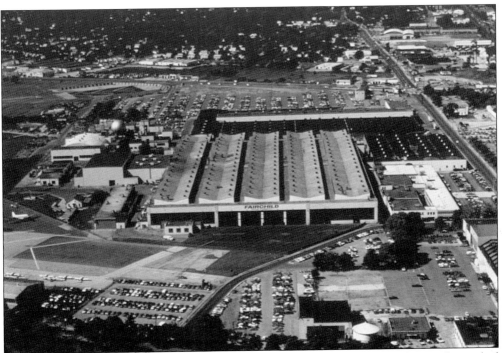

By the beginning of the 1980s, Fairchild Republic was approaching 10,000 employees who worked on the A-10 program and several subcontract programs, such as the Boeing 747 leading edges and the space shuttle vertical stabilizers. There were about six buildings that made up the company campus in Farmingdale. (Courtesy of Fairchild Republic Archives, CAM.)

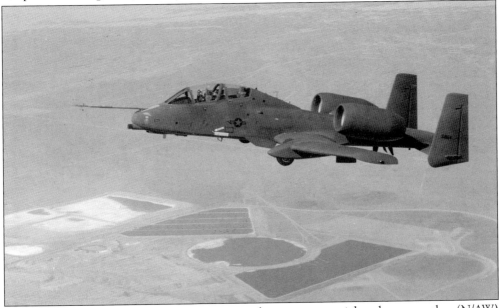

In 1979, an early production A-10 was converted to a two-seat night adverse weather (N/AW) version, which was designed to reduce the pilot's workload with an additional crew member in the back. The aircraft was modified in Farmingdale and flight-tested at Edwards Air Force Base. No orders developed. (Courtesy of Fairchild Republic Archives, CAM.)

In addition to Fairchild Republic, there were other aircraft manufacturers in the Farmingdale area. EDO moved to Farmingdale in the 1970s in order to flight-test aircraft with EDO aluminum floats for seaplanes until the company was sold to Kenmore Air during the 1990s. (Courtesy of LIRAHS.)

Republic Aviation created the Paul Moore Research & Development Center on Route 110 in Farmingdale in 1961. Fairchild closed the center when it took over Republic in 1965. The complex was used by Airborne Instrument Labs (AIL) and is presently used by the Telephonics Corporation. (Courtesy of LIRAHS.)

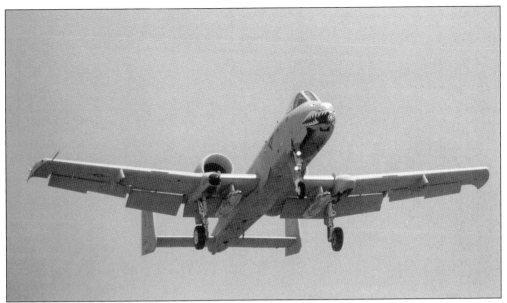

Although the A-10 was not flight-tested at Republic Airport, it has made occasional appearances at Republic Airport for special events and airshows. The A-10 was officially designated the Thunderbolt II in honor of the original P-47 Thunderbolt, though it was often called the Warthog. (Courtesy of Ken Neubeck.)

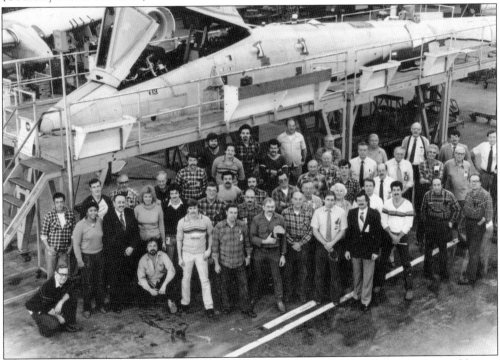

The fuselage section of the last A-10—Serial Number 713—is pictured in the final assembly area of the Fairchild Republic plant in Farmingdale in early 1984, prior to shipping to Hagerstown. With no more follow-up work on the A-10, the company only had the T-46A trainer program in the plant. (Courtesy of Fairchild Republic Archives, CAM.)

The second T-46A aircraft, designated T-2, is being towed on Conklin Street, adjacent to the Fairchild Republic buildings, in 1986. The aircraft has been masked for painting and has a protective tarp on the wings. (Courtesy of Fairchild Republic Archives, Ken Neubeck.)

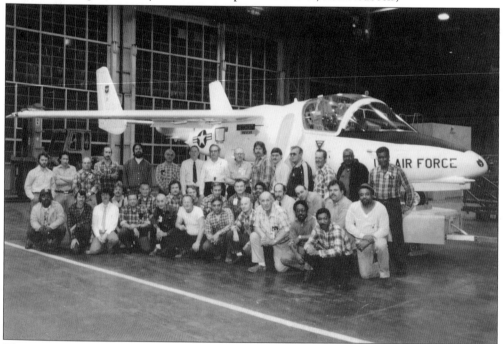

The second T-46A aircraft has just been painted in the company paint shop and is on display with workers in the final assembly area of the plant. This aircraft would fly at Republic Airport a few weeks later during the summer of 1986. LIRAHS trustee Mike Morra is second from the right in the second row. (Courtesy of Fairchild Republic Archives, LIRAHS.)

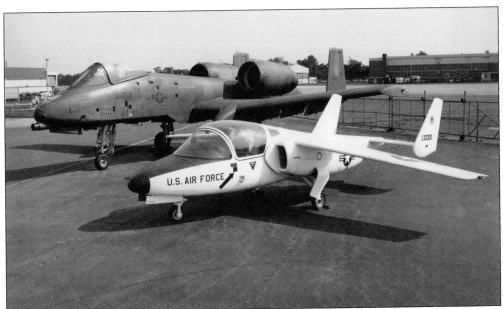

The last prime contract in Fairchild Republic was the T-46A Next Generation Trainer, which is pictured in front of the A-10. Due to financial issues and difficulties between the company and the Air Force, the contract was terminated in March 1987 after just three aircraft were built. (Courtesy of Fairchild Republic Aviation Archives, LIRAHS.)

The company closed by the end of 1987, and the buildings were abandoned. Before any new development could begin, there were major environmental concerns in the soil that needed to be addressed. A fire in November 1994 inflicted major damage to the buildings. This is now part of the Airport Plaza shopping center. (Courtesy of Ken Neubeck.)

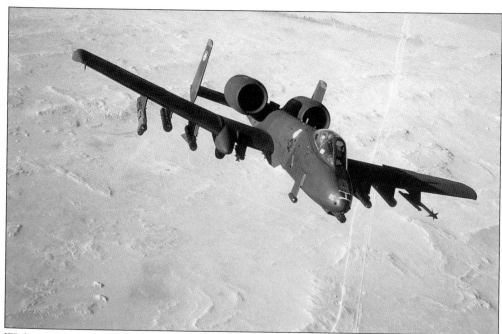

Without Fairchild Republic in business, support of the A-10 aircraft was handled by Grumman. In February 1991, the A-10 was involved in combat for the first time in Operation Desert Storm, where it destroyed over 1,000 Iraqi tanks in one month. (Courtesy of United States Air Force.)

A number of A-10 aircraft were hit with ground fire but returned to base due to the built-in survival features added by Fairchild Republic. This aircraft from the 23rd Tactical Fighter Wing was flown back to base by the unit commander after a hit to the tail section from a surface-to-air missile. (Courtesy of United States Air Force.)

Six

REPUBLIC AIRPORT
1966–PRESENT

Although the closing of Fairchild Republic in 1987 ended airplane manufacturing in Farmingdale, Republic Airport continues to serve as an important link in the national and international air network.

Republic Airfield became Republic Airport on December 7, 1966, and Fairchild sold the field to the Farmingdale Corporation, which had Flight Safety Inc. operate the field, with Fairchild Hiller using the airport. In 1969, the Metropolitan Transportation Authority (MTA) took over the airport and enlarged it to 525 acres, installing an instrument landing system on the 6,800-foot Runway 14-32 and working with the Federal Aviation Administration (FAA) to open Republic's modern control tower in 1982. The MTA also expanded airport operations to the west and south and built the Republic Airport Terminal Building.

A general aviation airport, Republic serves as a convenient location for privately owned jets and charter aircraft that come to Long Island. The airport is home to corporate aircraft and smaller, general aviation aircraft and serves as a base for aircraft that participate in the annual Jones Beach Airshow.

The New York State Department of Transportation (NYSDOT) has made major improvements since acquiring the airport in 1983. It has worked with the FAA to upgrade and modernize runways, taxiways, lighting, signage, security, and safety. The NYSDOT cooperated with federal, state, and local disaster relief agencies to facilitate the delivery of relief supplies and services after Hurricanes Irene and Sandy. The NYSDOT has also cooperated with the US Customs and Border Protection to enhance security at Republic Airport.

The NYSDOT has cooperated with SUNY Farmingdale to establish its Aerospace Education Center at the airport; the New York State Police to locate its Troop L headquarters at Republic; TV and movie companies to film scenes; and the American Airpower Museum to establish its popular museum at the airport. Two modern hotels have been brought into service, and businesses providing corporate and light general aviation services have expanded in all sectors of the airport. The NYSDOT, working with the Republic Airport Commission, established a preferential runway system to divert airplanes away from nearby residential areas and a noise complaint system to improve relations with airport tenants, local governments, and residents in surrounding communities.

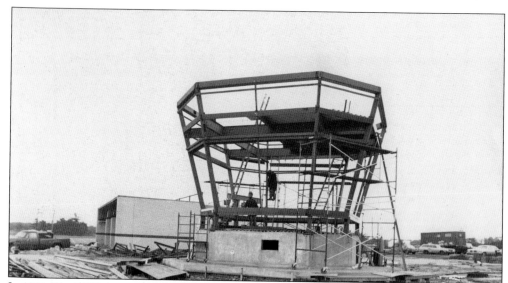

In 1981, The MTA began construction on the new FAA control tower and administrative offices at Republic Airport. Pres. Jimmy Carter signed the construction appropriation bill sponsored by Rep. Jerome Ambro in 1979. The tower cab is pictured, awaiting lifting and placement. (Courtesy of FAA-Farmingdale.)

A C-130 transport aircraft flies past the Republic Airport FAA control tower in May 2012. The current control tower (Republic Airport's third control tower) became operational in 1983. (Courtesy of Ken Neubeck.)

In 1982, the Republic Airport Commission (RAC) was created to advise the NYSDOT on the administration of the airport. The nine members of the RAC in 1986, from left to right, were (first row) Louis Avallone, Helen Norjen, and Maurice Black; (second row) vice chairman Lawrence Hornstein and chairman John Van Schoor; (third row) Peggy Marino, Thomas Portela, Charlotte Geyer, and Geoff Maddocks. (Courtesy of Republic Airport.)

Republic Airport is a very attractive location for film companies, since it provides privacy, open spaces, parking, and striking airport structures. Pictured is part of the Republic Airport terminal building set up to look like a small airport in Maine for the filming of scenes for the TV show *Damages*. (Courtesy of Republic Airport.)

The Long Island Republic Airport Historical Society (LIRAHS) worked with the Republic Airport Commission in 2000 to name the streets adjoining the airport after major companies in the history of the airport. From left to right are Lynn McDonald, LIRAHS president; Josephine Rachiele, LIRAHS treasurer; Jeanette Sinotte, Farmingdale State College official; Hugh Jones, airport director; and Frank Nocerino, airport chairman. (Courtesy of LIRAHS.)

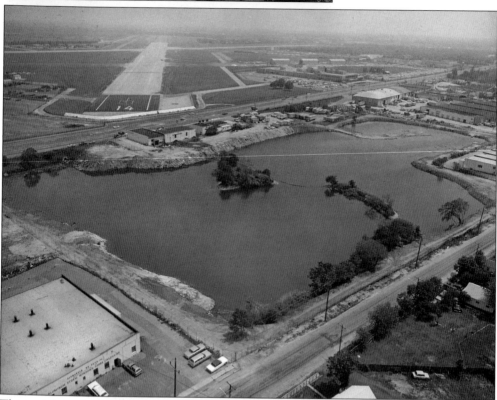

This aerial view looks southwest onto Republic Airport's runway 14-32 in the early 1980s. The sump in the foreground, which is not a part of the airport, was used for decades by Republic Aviation and Fairchild Republic to discharge waste waters and industrial waste, which environmental agencies later determined contained pollutants. The sump, on the west side of Route 110, was filled in with debris from the demolished Fairchild Republic factories in the late 1990s. (Courtesy of LIRAHS.)

During FEMA operations conducted as a result of Hurricane Sandy, which ravaged Long Island in October 2012, the airport served as a staging area for FEMA personnel as well as supply drops by Air National Guard C-130s, which landed daily at the airport. (Courtesy of Ken Neubeck.)

During recent Memorial Day weekends, Republic Airport has served as a staging area for aircraft participating in the Jones Beach Air Show. This includes the US Navy Blue Angels demonstration team, which is pictured flying the triangle pattern over the airport on their return from maneuvers over Jones Beach on May 24, 2014. (Courtesy of Ken Neubeck.)

A major safety improvement at Republic Airport in recent years has been the construction of Engineered Material Arresting Systems (EMAS) at both ends of Republic's ILS Runway 14-32. The EMAS consists of materials that slow down aircraft at takeoff, preventing aircraft from intruding onto New Highway, the Southern State Parkway, or Route 110. (Courtesy of NYSDOT.)

Building 5, the original 1928 Fairchild Airplane Manufacturing factory, is one of the last remaining historic Fairchild Republic Company buildings still intact, although gutted. It has been abandoned since 1987. (Courtesy of Ken Neubeck.)

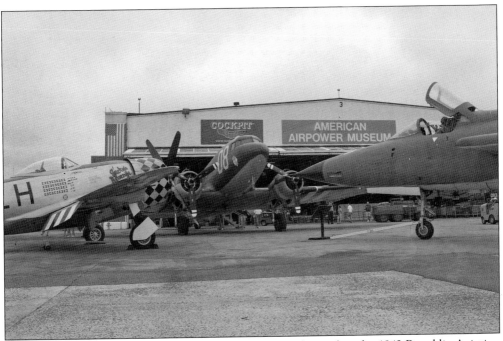

Throughout the year, the American Airpower Museum, located in the 1942 Republic Aviation final assembly hangar, conducts events that feature flying vintage World War II aircraft, including the P-47D pictured at left and the C-47 transport in the center. These complement the static display aircraft at the museum, such as the F-105D on the right. (Courtesy of John Musolino.)

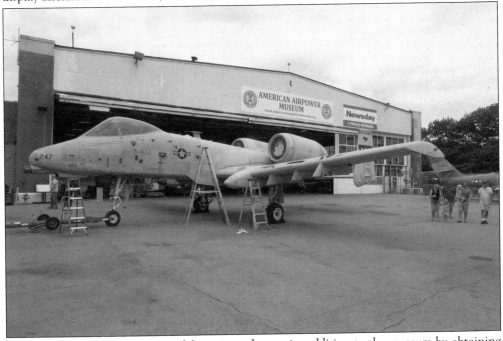

In 2014, the American Airpower Museum made a major addition to the museum by obtaining an A-10 Warthog that was retired from Air Force service. The museum has repaired and restored this aircraft for public viewing. (Courtesy of Ken Neubeck.)

Every year on December 7, the American Airpower Museum hosts a "Dropping of the Roses" ceremony to remember the events of Pearl Harbor. It is sponsored by the Long Island Air Force Association. Pictured is the 2012 gathering of veterans and various officials who take part in the ceremony. (Courtesy of Ken Neubeck.)

The Pearl Harbor remembrance event at the American Airpower Museum concludes with roses being presented by representatives from the branches of the US military to crewmembers of one of the GEICO Skytyper T-6 Texan aircraft, who transport and then drop the roses over the Statue of Liberty. (Courtesy of Ken Neubeck.)

Former Republic Airport director for the NYSDOT, Michael Geiger, tells young students about the Republic P-47 during the airport's Aviation Career Day. The associated lectures, aircraft displays, and educational opportunities motivate area students to consider careers in aviation. (Courtesy of Leroy Douglas.)

Republic Airport Commission officials are seen here in 2013. From left to right are Shelley LaRose Arken, Republic Airport manager; Subi Chakraboti, NYSDOT director, Region 10; RAC members Stella Barbera, Robert W. Bodenmiller, and Richard Grant; Frank Nocerino, chairman; RAC members Vincent Bologna Jr. and Joan Flaumenbaum; Michael Geiger, Republic Airport director; and John Arancio, assistant airport manager. (Courtesy of NYSDOT.)

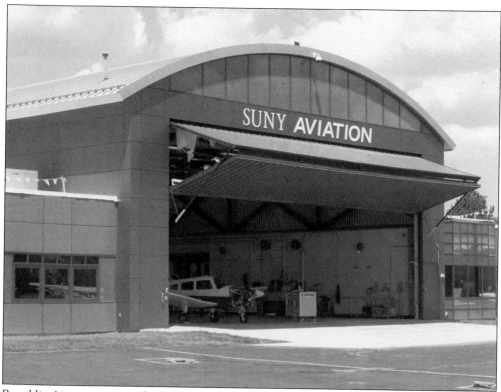

Republic Airport is currently the home of SUNY Farmingdale aviation school, which was built in 1993. The school has a four-year aviation program and owns 22 aircraft, including 12 Piper Warrior IIIs, one of which is in the hangar for maintenance. (Courtesy of Ken Neubeck.)

Republic Airport is a major center for private and commuter jets. Pictured is a recent event that focused on these civilian jets. (Courtesy of NYSDOT.)

During the course of a week, many different types of aircraft visit Republic Airport. The Atlantic City Coast Guard MH-65 helicopters use the airport as a refueling spot during their patrols along the northeast Atlantic coast from Virginia through Connecticut. (Courtesy of Ken Neubeck.)

The airport sees civilian aircraft traffic on a daily basis. Vintage aircraft are based at the American Airpower Museum. The Geico Skytyper T-6 Texan aircraft, pictured, waits for takeoff. (Courtesy of Ken Neubeck.)

This is the Republic Airport terminal and administration building, which houses the airport's fire safety and maintenance facilities. It also houses the Long Island Republic Airport Historical Society's historical exhibits and archives. (Courtesy of Ken Neubeck.)

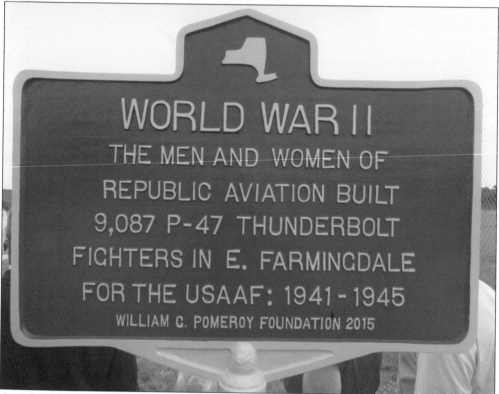

WORLD WAR II
THE MEN AND WOMEN OF
REPUBLIC AVIATION BUILT
9,087 P-47 THUNDERBOLT
FIGHTERS IN E. FARMINGDALE
FOR THE USAAF: 1941-1945
WILLIAM C. POMEROY FOUNDATION 2015

On July 21, 2015, the Long Island Republic Airport Historical Society organized a public dedication ceremony to unveil this roadside historical marker, which honors the men and women of Republic Aviation who built over 9,000 P-47 Thunderbolts in East Farmingdale during World War II. The marker was funded by the William C. Pomeroy Foundation and erected by the NYSDOT at Republic Airport very close to the site of the former Republic factory complex. (Courtesy of Ken Neubeck.)

BIBLIOGRAPHY

Abel, Alan. *Fairchild's Golden Age*. Brawley, CA: Wind Canyon Books, 2008.

Bodie, Warren M. *Thunderbolt: From Seversky to Victory*. Hiawassee, GA: Widewing Publications, 1994.

Dade, George C. and Frank Strnad. *Picture History of Aviation on Long Island*. New York, NY: Dover Publications, 1989.

Douglas, Roy. "The Conklin Street Cut-Off, Part 1." *Long Island Forum* 47 (August 1984) 155-161.

————. "The Conklin Street Cut-Off, Conclusion." *Long Island Forum* 47 (September 1984) 181-186.

————. "Robert Moses and the F-84-F Runway Fight." *Long Island Forum* 49 (March 1986) 44-51.

————. "The Origins of Airplane Manufacturing in Farmingdale, New York: 1917–1928." *Nassau County: From Rural Hinterland to Suburban Metropolis*. Interlaken, NY: Empire State Books, 2000.

————. "Farmingdale's Submarine: The Fairchild X-1." *The Nassau County Historical Society Journal*, Volume 69, 2014.

————. "From Farmland to Aviation Center: The Origins of Republic Airport." *Long Island Forum* 53 (Summer 1990) 81-88.

Francillon, Rene J. *Grumman Aircraft Since 1929*. Annapolis, MD: Naval Institute Press, 1989.

Machat, Mike. *World's Fastest Four-Engine Piston-Powered Aircraft: Story of the Republic XR-12 Rainbow*. North Branch, MN: Specialty Press, 2011.

Mitchell, Kent A. *Fairchild Aircraft: 1926–1987*. Santa Ana, CA: Narkiewicz/Thompson, 1997.

Neubeck, Ken. *A-10 Warthog*. Carrollton, TX: Squadron/Signal Publications, 1995.

————. *A-10 Warthog Walk Around*. Carrollton, TX: Squadron/Signal Publications, 1999.

————. *F-105 Thunderchief Walk Around*. Carrollton, TX: Squadron/Signal Publications, 2000.

————. *F-105 Thunderchief in Action*. Carrollton, TX: Squadron/Signal Publications, 2002.

————. *F-84F Thunderstreak Walk Around*. Carrollton, TX: Squadron/Signal Publications, 2009.

Stoff, Joshua. *The Aerospace Heritage of Long Island*. Interlaken, NY: Heart of the Lakes Publishing, 1989.

————. *The Thunder Factory: An Illustrated History of the Republic Aviation Corporation*. Osceola, WI: Motorbooks International, 1990.

————. *Long Island Airports*. Charleston, SC: Arcadia Publishing, 2004.

————. *Long Island Aircraft Manufacturers*. Charleston, SC: Arcadia Publishing, 2010.

Thruelsen, Richard. *The Grumman Story*. New York, NY: Praeger Publishers, 1976.

DISCOVER THOUSANDS OF LOCAL HISTORY BOOKS
FEATURING MILLIONS OF VINTAGE IMAGES

Arcadia Publishing, the leading local history publisher in the United States, is committed to making history accessible and meaningful through publishing books that celebrate and preserve the heritage of America's people and places.

Find more books like this at
www.arcadiapublishing.com

Search for your hometown history, your old stomping grounds, and even your favorite sports team.

Consistent with our mission to preserve history on a local level, this book was printed in South Carolina on American-made paper and manufactured entirely in the United States. Products carrying the accredited Forest Stewardship Council (FSC) label are printed on 100 percent FSC-certified paper.

MADE IN THE USA